BLUE

BLUE

In Search of Nature's Rarest Color

KAI KUPFERSCHMIDT

THE EXPERIMENT

NEW YORK

BLUE: *In Search of Nature's Rarest Color*
Copyright © 2019 by Hoffmann und Campe Verlag, Hamburg
Translation copyright © 2021 by The Experiment, LLC
Page 213 is a continuation of this copyright page.

Originally published in Germany as *Blau* by Hoffmann und Campe Verlag, Hamburg, in 2019. First published in English in North America in revised form by The Experiment, LLC, in 2021.

The Experiment, LLC
220 East 23rd Street, Suite 600
New York, NY 10010-4658
theexperimentpublishing.com

THE EXPERIMENT and its colophon are registered trademarks of The Experiment, LLC. Many of the designations used by manufacturers and sellers to distinguish their products are claimed as trademarks. Where those designations appear in this book and The Experiment was aware of a trademark claim, the designations have been capitalized.

The Experiment's books are available at special discounts when purchased in bulk for premiums and sales promotions as well as for fund-raising or educational use. For details, contact us at info@theexperimentpublishing.com.

Library of Congress Cataloging-in-Publication Data

Names: Kupferschmidt, Kai, author.
Title: Blue : in search of nature's rarest color / Kai Kupferschmidt.
Other titles: Blau. English
Description: New York : The Experiment, 2021. | Originally published in
 Germany as Blau by Hoffmann und Campe Verlag, Hamburg, in 2019. | Includes
bibliographical references.
Identifiers: LCCN 2021001385 (print) | LCCN 2021001386 (ebook) | ISBN
 9781615197521 | ISBN 9781615197538 (ebook)
Subjects: LCSH: Blue. | Colors. | Colors in nature.
Classification: LCC QC495.8 .K8713 2021 (print) | LCC QC495.8 (ebook) |
 DDC 535.6--dc23
LC record available at https://lccn.loc.gov/2021001385
LC ebook record available at https://lccn.loc.gov/2021001386

ISBN 978-1-61519-752-1
Ebook ISBN 978-1-61519-753-8
Inquisitive, Inc., edition ISBN 978-1-61519-846-7

Jacket and text design by Beth Bugler
Cover photograph by iStock.com/Hans Harms
Author photograph by IMAGO/Sven Simon
Translation by Mike Mitchell

Manufactured in China

First printing May 2021
First printing Inquisitive, Inc., edition March 2021
10 9 8 7 6 5 4 3 2 1

HAPPY YOU WHO CAN BE DRUNK FROM THE BLUE OF THE SKY

—KURT MARTI

CONTENTS

INTO THE BLUE

A sea of blue thoughts
pours forth over my heart.

—HEINRICH HEINE

One of the most famous photos of all time was not taken on Earth. It shows Earth. On December 7, 1972, the astronauts of Apollo 17, the last manned Moon mission, aimed a camera at their—our—home planet.

On the globe, Africa and the Arabian Peninsula can be seen in shades of green and brown. From the ice cap around the South Pole white clouds seem to be swirling away, as if in a Van Gogh. The rest is blue: the Indian and Atlantic Oceans, the Red Sea and the Mediterranean. *The Blue Marble*—that's how the photo has come to be known.

A few years ago, I was traveling on one of those patches of blue. It was summer, and I was standing on the deck of a ferry taking me from Athens to one of the numerous Greek islands. Suddenly a question flashed through my mind: How would I explain the color blue to a blind person?

Curving above me was the shining blue of heaven and, stretching out all around me, the deep sea blue of the Aegean. I felt I was hovering between those two spheres of infinite blue. It was a sublime moment. But how could I explain that feeling to someone who didn't know what blue is?

And what is blue, anyway?

Is the color cool? Calm? Wet? Is blue the taste of blueberries? The smell of the sea? The feeling you have when your teeth are chattering with cold?

It is no accident that this question occurred to me about blue of all colors. Throughout the world, blue is the most popular color for both men and women. Goethe felt that the color had "a peculiar and almost indescribable effect on the eye." In the Middle Ages, the pigment ultramarine was worth its weight in gold. Pablo Picasso had his Blue Period, and the painter Henri Matisse was fascinated by a blue butterfly. The French artist Yves Klein saw the transition from the material to the immaterial in the color. "The deeper the blue the more it beckons man into the infinite, arousing a longing for purity and the supersensuous," wrote Wassily Kandinsky, one of the founding members of the group of artists known as the Blue Rider.

"Colour is first and foremost a social phenomenon," the cultural historian Michel Pastoureau wrote in his book about the history of blue.

It is that, too. But above all? Is the sky a social phenomenon? The sea? A rainbow? Is the sense of vastness that blue creates?

Blue is physics. Back then, aboard the ferry, I couldn't have explained it precisely, but I knew that the sky and the sea are blue because light of a certain wavelength interacts in a particular way with the molecules in the air and the water.

Blue is chemistry. Lapis lazuli develops under certain conditions in Earth's crust when limestone comes into contact with hot magma. Dyeing with indigo demands some clever chemistry in order to transfer the blue pigment to cloth; it is the behavior of these pigment molecules that we have to thank for our much-loved denim. And one of the shades of blue used by Picasso was developed by alchemists in Berlin, who were actually looking for a wonder drug to cure all disease.

Blue is biology. Long before painters were bringing beauty to a canvas with their brushes, there were shimmering blue butterflies and flowers blooming in blue. Evolution produced

them, as it did our ability to appreciate the colorful spectacle of life.

Blue is special. It occurs less frequently in nature than other colors do, as Goethe himself noted in his *Theory of Colours*. Why? What does science know about the color blue? What is the connection between all these things we admire: the butterflies and the berries, the sea and the stones and our senses? How much more beauty is there for us to discover if we know what it is that connects them? In short: How would I explain blue to a person who *can* see?

Blue stones such as lapis lazuli or sapphire derive their color from grids of crystals in which elements such as sulfur, iron, copper, or cobalt arrange themselves in a particular way. Humans have learned from some of these stones how to create inorganic pigments in order to use them in our art. In plants, it is organic pigments, large molecules based on carbon, that make them appear blue. These inorganic and organic pigments form the basis of most of the shades of blue around us.

In the animal world, blue comes about in a different way. Most animals manage without any blue pigments. Instead, tiny patterns on their bodies' surfaces manipulate rays of light directly so that blue light is intensified. In birds' feathers and butterflies' scales, nature has mastered a technology that humans are only just beginning to understand at the dawn of the twenty-first century.

Yet the beauty of all these stones, plants, and animals also lies in the eye (and brain) of the beholder. Our eyes transform the rays of light they reflect into electrical signals, our brain interprets these signals, and our language arranges these impressions into colors. Blue is not out there, and it is not inside us, either. The radiant blue of a cornflower is a kind of collaboration between us and the plant.

The poet John Keats felt that Isaac Newton had "unweaved" the rainbow. But science is actually doing the opposite, elucidating what holds the world together at its core. It reveals connections where we do not suspect any, until we discern the blue of a butterfly's wing in the shimmer of a soap bubble; the blue of lapis lazuli in a painting in the museum; or the blue of the sky in a friend's blue eyes.

That may not sound like much, but I hope that it is enough to let us see the beauty of nature. My hope is that my illuminating these connections will allow us to see the beauty of nature with fresh eyes. And perhaps it will also help us to better understand the beauty, fragility, and sheer improbability of our blue planet and the responsibility we bear toward it. Or, as the American poet Archibald MacLeish wrote after Apollo 8, the first Moon mission, on the front page of *The New York Times*, "To see the earth as it truly is, small and blue and beautiful in that eternal silence where it floats . . ."

These stones we do employ
to bring us bliss and joy,
from them we take ultramarine
the rarest color ever seen.

—BARTHOLD HEINRICH BROCKES

The mineral azurite is one of the oldest
blues made use of by humans. In its
natural state it often appears together
with green malachite.

The first Italian sentence I ever learned (and not many have been added since) was: *Mi fa uno sconto?* ("Would you give me a discount?") That's what it said in the little Italian phrase book my parents had brought along on our family holiday in Italy. And so that's what I said to the old man in the gem shop.

I had discovered a stone in his window display that seemed to magically attract me. The stone was azure blue and translucent. It reminded me of the sea, and I wanted to have it. Only my pocket money wasn't enough. "This is Italy," my father said. "You have to haggle." So I dutifully learned my first Italian sentence by heart and staggered back to the little shop after the siesta.

The miracle happened. I got the stone for the money I had. I can no longer remember how much of a discount the shop owner gave me. I think it was a great deal.

Back then I was going through my stone phase. At home I had pyrite with its golden gleam, moss-green malachite, and neon-yellow sulfur, all neatly set out. I also had a little white porcelain tablet with a rough surface that I could scrape a stone on. The color of the line left by the stone, its "streak," could help determine what mineral it was.

All that seemed to be fine by my mother, and certainly preferable to my animal phase, when I'd collected wood lice and

insisted on keeping a bucket full of soil with worms in it in my room overnight. (What seemed to disturb her most of all was my disappointed announcement over breakfast the next morning that the worms were no longer anywhere to be found in the bucket.)

I knew that for a true collector, a mineral has no value unless its origin has been documented. And yet in the case of this blue stone, for which I had neither a name nor a source, that didn't bother me. Its color made up for everything.

Over the years, countless other minerals were added, and it was always the blue ones that fascinated me the most: a little spicule of tourmaline, fragile and dark blue; a tiny sapphire, perhaps the most valuable piece in my collection; and a lapis lazuli—like a petrified piece of sky with white clouds of calcite and glittering stars of pyrite.

I knew that these inorganic blues were different somehow from those in the animal and plant kingdoms. But in what way, exactly? How could inanimate nature, Earth, bring forth these fantastic colors? And how were they related to the blues of the works of art I'd seen in the Uffizi Galleries during that same holiday in Italy? I already had these questions back then. I could not have guessed that more than twenty years later, thousands of miles away, I would finally get some answers.

BLUE LIGHT

When the blue light flares up behind me, I'm immediately wide awake again. And that's a good thing. Because it's the middle of the night—very much so counting the jet lag—and I am, after all, at the wheel of a car. My flight from New York to Portland, Oregon, was delayed and landed after midnight, and then

I'd rented a car to travel to Corvallis, over ninety miles south. With one eye on Google Maps and the radio blaring to keep me awake, I'd been racing along the empty streets. At around three in the morning, finally nearing my destination, I see the blue light of the patrol car. I pull up along the side of the street, only about 30 feet (9 m) from my hotel.

In Germany, where I live, police cars, fire engines, and ambulances use flashing blue lights to announce their presence, and the flashing lights are simply called *blaulicht*, blue light. But as the policeman gradually grows larger in the side mirror, it occurs to me that "blue light" is actually the wrong term here. On top of the police car both red and blue lights are flashing. In some ways that makes a lot more sense than using blue light alone.

Before electric light became standard, the fire department's emblem was a kerosene lantern. The firefighters announced their arrival with fire. In the 1920s, red electric light began to replace the lantern in many countries. Eventually red was generally recognized as the color of warning, and it is easy to see. But in May 1938, Germany switched to blue light (using a solid cobalt blue glass encasing the bulb). The Second World War was literally casting a shadow on the nation in the form of blackout requirements. The law prescribed that no light should be seen "at times of darkness and clear visibility from 500 meters altitude." Because of its short wavelength, blue light is scattered more in the atmosphere, which makes it harder to spot from an airplane. So the German police actually began to use blue light so as *not* to be seen from a distance.

I don't bother the officer with my thoughts about his warning lights; I hand him my license instead. Twenty minutes and a verbal warning later (for switching lanes without signaling), I'm finally lying in bed and thinking, *I hope this whole journey is worth it.*

I have come to Corvallis looking for answers. I have come to meet Mas Subramanian, a chemist who, a few years ago, discovered a new blue.

MORE BLUE

The next day I'm in Subramanian's lab. On the bench in front of me are the instructions for making 10 grams of his blue pigment. They fit easily on a small sheet of paper:

4.5392 grams of yttrium oxide
5.302 grams of indium oxide
0.1585 grams of manganese oxide

Mix together and then bake at 1300 degrees Celsius for at least six hours in the oven.

A lab assistant gives me the three basic materials: white yttrium oxide, dirty-yellow indium oxide, and black manganese oxide. The most difficult part is weighing out the precise amounts. A tiny bit more on the point of a spatula. Then take some away again. Take away a little more, then add a tiny grain again.

Eventually it all ends up in a mortar, and I grind it down with a pestle until it's a uniform gray powder, which I compress into two large tablets, making it easier for the ingredients to combine into a new substance in the furnace.

It is difficult to believe that this gray will be transformed into a bright blue.

While we're waiting, Subramanian tells me how, as a child, he used to go read in the British Council library. He was born in Chennai, in southern India, in 1954. Once he found a book in

the library about the careers of famous scientists; one of the researchers portrayed was the chemist Linus Pauling. Pauling had helped to establish the structure of proteins and how chemical compounds arise. After the Second World War, he had joined the peace movement, and eventually he became one of the few people to be awarded two Nobel Prizes: the Peace Prize and the prize for chemistry.

But it was one small detail that fascinated the thirteen-year-old Mas: Linus Pauling was born on the same day as him, February 28. "I thought, why shouldn't I become like this person? At least we were born on the same day." On the way home from the library—a few miles he covered on foot in order to save the bus fare—he couldn't stop thinking about that, Subramanian recalled. "It was incredibly naive."

Subramanian studied chemistry, earned a PhD, then went to Texas and eventually took a job with DuPont, one of the largest chemical companies in the world. In 2006, after working there for twenty years, Subramanian left the company and transferred to Oregon State University. It was the university where Linus Pauling had begun his research.

Three years later, Subramanian discovered his new blue.

The sight was a shock, Subramanian says. And it is the same for me when the oven is opened again the next day. The two tablets are blue, a deep blue. It is as if someone had transferred the essence of the idea of "blue" into material. It was the "bluest blue" he'd ever seen, the historian Simon Schama wrote.

The official name of the pigment consists of the symbols for the elements involved: Y, In, Mn: YInMn blue (pronounced "yinmin"). Sometimes Subramanian jokingly calls it "MasBlue"; after all, that's not just his first name—in Spanish, *mas* also means "more."

For Subramanian it was the discovery of a lifetime: the first new blue pigment in inorganic chemistry in two hundred years.

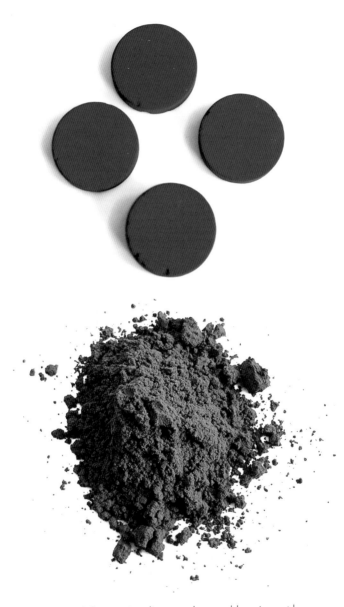

The scientist Mas Subramanian discovered a new blue pigment by chance in 2009.

He had published hundreds of scientific articles, he tells me, and applied for dozens of patents (he had discovered a new superconductor, for example, and a more environmentally friendly way of manufacturing the chemical fluorobenzene), but none of his discoveries so excited the public as his new blue. International media reported on it; artists and entrepreneurs tried to get their hands on it. His discovery inspired a music festival in Atlanta and a new crayon from Crayola. It seemed as if the world simply couldn't get enough of the new color. And this was just the latest episode in humanity's obsession with blue, which goes back thousands of years.

BLUE FROM OUT OF EARTH

As far back as a hundred thousand years ago, our ancestors were mixing the first pigments from ferrous minerals. In the Blombos Cave in South Africa, researchers have found abalone shells containing residues of colors. Clearly, early humans were using yellow and red ocher, charcoal, ground-up bones, and other materials, mixing them with fat in order to make the earliest pigments.

What use was made of these colors is unclear. The inhabitants of the Blombos Cave may have painted their skin with them. One thing is clear, though: These early artists had a very restricted palette to paint with. The Blombos Cave is only a few yards away from the magnificently blue Indian Ocean, but there are no indications that the people of that time had a pigment they could use to apply that color to their skin, objects, or walls.

At some point *Homo sapiens* started to paint or spray depictions of animals on the walls of caves: bison and bears, horses, stags, rhinoceroses, and mammoths. But even in those images

no trace of the color blue can be found. The color of the sky and the sea could not be extracted from the ground. And it remained that way for tens of thousands of years.

Humanity eventually discovered a supply of blue in the mountains of the Hindu Kush, in present-day Afghanistan. Lapis lazuli (the name simply means "blue stone") was already being worked into items of jewelry there seven thousand years ago. In the thirteenth century Marco Polo described those mountains "in which are found veins of lapis lazuli, the stone which yields the azure color." The azure was, he went on, "the finest in the world." Today lapis lazuli is also mined in Chile, Russia, and Pakistan. But the most beautiful lapis lazuli is still to be found in the Sar-e-Sang mine in the Hindu Kush.

To be precise, lapis lazuli is not a mineral but a rock, a mixture of minerals. The most important of these is lazurite, the one that gives lapis lazuli its blue coloring (there are atoms of sulfur in lazurite that bring about the blue coloration, but more about that later). Lazurite in its pure form is rare, but every now and then collectors find wonderful cube-shaped crystals that look as alien as the monolith in Stanley Kubrick's *2001*. Had I known about lazurite as a child, I would have absolutely wanted to have it in my collection.

In lapis lazuli, lazurite is mostly mixed with golden pyrite, white calcite, and other minerals such as afghanite and titanite. That is why, when the stone is ground down, you don't get a brilliant blue pigment but a pale-gray powder instead. It took something other than the blue from the mountains to finally get a decent blue to paint on the wall.

COLOR OF THE PHARAOHS

The Egyptians, too, were addicted to the blue of lapis lazuli. The stones from the Hindu Kush were treated as precious jewels in ancient Egypt. In the magnificent death mask of Pharaoh Tutankhamun the eyebrows of the godlike king are made of lapis lazuli. Rare and precious, even the smallest pieces of the stone were used and reused over and over again.

In Tutankhamen's grave there were thousands of other lapis lazuli objects, many of them composed of small pieces of stone. A beetle has a small circle on its back, reminiscent of the stone's earlier life as a bead on a necklace. And among the treasures of the kings of the twenty-first dynasty there is a really beautiful double string of fifty-six lapis lazuli beads. One of these beads is especially blue, and if you look closely you can see three lines in cuneiform script engraved on it—a dedication from an Assyrian vizier to his daughter, inscribed a few hundred years before the time of the pharaoh in whose grave it ended up.

Perhaps it was their exceptional love for blue; perhaps it was chance. But whatever the case, the Egyptians succeeded in doing what previous people had attempted in vain: They made blue.

In the desert to the west of the Nile, in Saqqâra, the city of the dead, stands one of the oldest monumental structures in the world: the step pyramid of Djoser. Djoser ruled Egypt about 4,700 years ago, and it was with him that the Old Kingdom, the glorious age of the pharaohs and pyramids, began. Anyone who has seen the pyramids in Giza may not be particularly impressed by this 205-foot-high monument in six steps. But when I was in Cairo in 2018 I made the trip to the south, less than an hour by car. For Djoser's pyramid stands not only at the beginning of all the pyramids, but also at the beginning of the history of blue, or, to be more precise, on top of it.

Under the pyramid lies the burial chamber of Djoser, surrounded by miles of tunnels, some of them lined with thousands of tiles with a bluish-green shine: perhaps the first blue made by man. The Egyptians mixed white pebbles, sandstone, copper ore, and soda into a powder. When water is added, a paste is produced that becomes a kind of ceramic in the kiln, with a solid (mostly white) core and a shining blue glazed outer layer. (Today you can see many of these tiles in New York's Metropolitan Museum of Art, in the British Museum in London, or right there in Saqqâra at the Imhotep Museum.)

The Egyptians may or may not have invented the formula, but they perfected it. And they created an incalculable number of objects with it. I spent a long morning strolling around the Egyptian Museum in Cairo, admiring blue vases, boxes, pendants, and goblets. There were amulets that had been wrapped up in the mummies' bandages to protect the dead in the underworld, and countless statuettes: of birds and beetles, gazelles and hippopotamuses, oxen, fruits, and hieroglyphs.

Blue ceramics were merely the beginning. There still wasn't a truly blue pigment that could be painted on walls, for example. For that, the Egyptians had to develop their blue arts even more. Around the time of Djoser's rule they finally succeeded in producing the first artificial pigment: Egyptian blue.

There are no records in Egypt of how the color was made. It was only a thousand years later that the Roman Vitruvius put a formula down on paper: sand, copper (probably in the form of metal filings or the mineral malachite), and soda, ground down, mixed, and fired in a kiln.

The grave of the Egyptian king Djoser was lined with tens of thousands of these blue-green tiles. They are 4,600 years old.

As a result, Egyptian blue is sometimes called blue frit—from the Italian *fritta*, meaning "fried." (I love the expression and have started to use it in my own way: When I'm a little drunk—which we call being blue in German—and can't resist a late-night heap of fries from a fast-food restaurant, I just say I'm in a blue frit.)

In the vicinity of Djoser's pyramid there are countless graves of officials from ancient Egypt, the walls of which are decorated with impressive paintings. You can still see the remains of that first blue in many of them, even today.

The story of Egyptian blue took one more turn—thousands of years later. In 1938 an Italian researcher described a new blue mineral he'd found on the slopes of Vesuvius. He gave it the name cuprorivaite. Two decades later the geologist Adolf Pabst deciphered the chemical structure of that mineral: It was the same as that of Egyptian blue. So that pigment had always existed—as stone. The Egyptians had not created a new blue. They had simply produced a natural substance artificially. The dream of a genuinely new blue would only be realized much later.

A TRAIL OF BLUE

It isn't easy to follow Egyptian blue down the centuries. When we look at sculptures from ancient Greece or Rome today, they are made of pure white marble, as a rule. This supposed ancient aesthetic was idealized during the Renaissance with not a little racism. "Since the color white is the one that sends back the most light beams, consequently making itself more sensitive, then a beautiful body will be all the more beautiful, the more white it is," wrote the German archaeologist (and white man) Johann Joachim Winckelmann.

But were most of the statues really white? Had the artists, once they'd discovered a blue, left it untouched?

This question took me to London, to one of the largest collections of art and antiquities in the world: the British Museum, more than 250 years old and the repository of more than eight million objects. It would take years to see everything that's displayed there. But I had come to see something that remains hidden from most visitors. The researcher Giovanni Verri was prepared to do a kind of conjuring trick for me.

Verri is Italian, and he talks quickly and is full of enthusiasm. Even as a child he had been fascinated by the art of antiquity and ancient Egypt. "When I was in London to learn English, I came here every day to look at the same objects," he says. But then, Verri studied physics instead of art history. ("The usual thing— your parents tell you you'll never get a job if you study something like that," he said.) He did a doctorate on nuclear fusion but managed to find his way back to antiquities, and started to use modern methods derived from physics to examine ancient objects, helping to preserve works of art. Today he works as a conservator at the renowned Courtauld Institute of Art.

In 2008 Verri was examining a wonderfully painted basin from ancient Greece when he noticed something interesting. Our human eyes can perceive only a very limited part of the electromagnetic spectrum. Nowadays, however, technology allows us to "see" with other wavelengths. Researchers examining works of art often use infrared light. Usually they shine it on a work of art and photograph the rays that are reflected. Since the light rays can penetrate the applied layers of color, this technique can, for example, uncover earlier sketches on the canvas, ones that the artist has painted over.

When Verri took photos of the basin in the infrared range, the blue designs on it glowed like the characters of a secret alphabet. Verri remembered that this effect had been described

years ago. Egyptian blue pigment absorbs visible light and emits light from the infrared spectrum in return.

Under normal conditions this weak infrared luminescence cannot be perceived because it is entirely outshone by the infrared light of the surroundings. But when Verri photographed the basin, the lighting was a simple neon tube, which, in contrast to a normal lightbulb, emits barely any infrared light—and that was why the Egyptian blue shone so clearly. Verri immediately realized that he could use this simple method to detect vestiges of color on ancient sculptures and paintings.

In the British Museum, Verri showed me a digital camera he had modified for this purpose. An optical filter that blocks infrared light is built into most digital cameras. Verri removed that filter and instead installed a filter in front of the lens that blocks visible light and lets through only infrared light.

Verri took me into the gallery of the mausoleum at Halicarnassus, one of the seven wonders of the ancient world. Among other things, a frieze from the tomb can be seen here, depicting Amazons and Greeks fighting each other. Verri raises the camera, there's a flash, and the image of a warrior from the frieze appears on the display, the hilt of a sword gleaming vividly in his hand. We go through several rooms, and the outlines of other weapons, bits of color, and designs on clothing appear in the flash of the modified digital camera. The eyes of some Roman sculptures light up with a ghostly glow: Clearly the artists mixed a little blue in to the whites of the eyes to make them look more realistic.

These things are entirely invisible to the naked eye, and the way long-hidden symbols appear in the flash of Verri's camera is eerie, as if it were revealing another dimension in which the colors of the weatherworn works of art are still there in their former splendor, shattering the myth of monochromatism.

For the art world, Verri's method is an important new tool. He was able to show, for example, that the famous Elgin Marbles, those sculptures Lord Elgin stole from the Acropolis in Athens and then sold to the British Museum, have traces of Egyptian blue. It confirms what was long suspected: In the past the Parthenon was not white, but painted blue.

Interpreting the traces Verri finds is difficult. The sword of the warrior on the frieze of the mausoleum probably wasn't blue. It's possible that the whole background of the frieze was blue, and a metal sword that was once there protected remnants of color so that they survived while the rest didn't.

Whatever the reason, just as the colors disappeared—peeled off, weathered, and sometimes even washed off by overzealous lovers of the alleged aesthetics of antiquity—Egyptian blue disappeared as well. At some point after the end of the Roman Empire, the formula was lost and the world was one tint the poorer. Artists in the Middle Ages had to get by with blue from other sources.

ACROSS THE SEA

A famous altar painting by the Renaissance artist Raphael hangs in the Metropolitan Museum of Art in New York. In the middle of it, Mary sits enthroned with Jesus in her lap. While the saints around her are luminous in colorful robes, Mary appears wrapped in a somber dark-green gown. In fact, the gown was originally a radiant blue. The pigment was obtained from the common deep-blue mineral azurite. It had already been employed in ancient times, but it was most widely used in medieval European painting.

The problem: Over time, azurite oxidizes and turns into green malachite, a mineral that often occurs in nature. That is

why Mary's gown in Raphael's painting seems so somber today.

An alternative to azurite was smalt, a kind of ground glass that derives its color from the element cobalt. From the sixteenth century onward, this blue pigment was manufactured in foundries around the world. Smalt is made by roasting cobalt ore, mixing it with quartz sand and potash, and then melting it down in a kiln. The result is a blue glass that can then be ground down. But there are several disadvantages to smalt, the most important of which, for artists, is that it, too, changes color over time.

The most coveted and stable blue in the Middle Ages was an old acquaintance: Lapis lazuli dominated the art world once again. Humans had finally found a way of transforming the blue of the stone into a vivid pigment. As ever, the most important source of lapis lazuli was in the Hindu Kush, and so, because of the long journey it took to get to Europe, it was called ultramarine ("from across the seas"). In addition to the rarity of the source material, there was the elaborate processing.

A book from the nineteenth century describes the procedure as follows: "In order to make ultramarine out of the lapis lazuli stones the pieces with the darkest coloring have to be selected, cleaned and pounded into coarse fragments. These are heated moderately in an earthenware crucible until red hot and, while still glowing, are poured into cold vinegar and left there for several days. These fragments become cracked by being poured into cold water and thus easier to grind down, and by having been left in the vinegar any chalk mixed in with it will have been dissolved. They are then ground down on a grinding-stone until they are the finest powder." That powder is then mixed with turpentine, resin, linseed oil, and wax; heated over a fire; and put into a water bath, where it hardens into a cake.

Then comes the crucial part: Warm water is poured over the cake, softening it, and it is carefully kneaded. During the process

of kneading, particles of ultramarine slowly seep into the water, leaving the other substances behind. Once the warm water has been poured off and left to stand for a while, the pure pigment gathers at the bottom. "The water that is poured off first of all deposits the most beautiful ultramarine; later pourings give a progressively less beautiful color."

The first pigment produced was more valuable than gold. In 1508 the artist Albrecht Dürer complained about the price in a letter to his patron Jacob Heller: no less than ten or twelve ducats for an ounce of ultramarine. Many contracts stipulated how much ultramarine and of what quality the painter had to use (and what the person commissioning it had to pay for it). Pope Julius II, for example, insisted that Michelangelo use ultramarine for the ceiling of the Sistine Chapel. Most artists, however, had to make do with cheaper shades of blue—at least until chemistry produced a completely new blue.

THE PHILOSOPHER'S STONE

Hanging over the entrance to the chemistry building at Oregon State University, where Subramanian has his office, is a stone tablet. In the center, the alchemical symbols for the four elements appear: water, air, fire, earth. Grouped around them are the symbols for some of the alchemists' classic materials: silver, sulfur, copper, lead, salt and chalk, arsenic, and potash.

That list includes all the ingredients for Egyptian blue. Indeed, one of alchemy's origins lies in the ancient Egyptians' experiments with color. By the beginning of the eighteenth century, however, the alchemists were no longer focused on making colors. They had a different goal. In the frieze over the entrance, the symbol for the element they sought

is resplendent in the top middle—a circle with a dot in the center: gold.

The legendary substance that was said to transform iron or lead into gold was called *lapis*, the "philosopher's stone." While the alchemists tried to transmute elements in vain, some of them achieved a different, no less impressive transformation: converting the credulity of some people into hard currency. At least for a while.

Few of these miracle workers were more successful than Domenico Manuel Caetano. When he came to Berlin in 1705, he had already honed his tricks in Naples, Venice, Verona, and Vienna, where he had deceived counts, kings, and cardinals. Caetano claimed to possess the philosopher's stone and convinced his audience of his ability by using, among other things, a cleverly prepared spoon for stirring made of gold coated in a layer of wax. In Berlin, Frederick I gave the highly regarded alchemist Johann Konrad Dippel the task of verifying Caetano's claims. Dippel was taken in by the con man, and from then on, the Prussian king, who was deep in debt, hoped for a shower of gold. But Caetano's lucky streak soon ended. Frederick received warnings from earlier victims, and when Caetano tried to flee, the king had him captured and brought back. Again Caetano tried to flee, and at that, the king gave him a year's grace to produce the desired gold. The swindler could not deliver, and on August 23, 1709, the self-styled Count of Ruggiero was publicly hanged in Küstrin.

A few alchemists produced real breakthroughs, however. Johann Friedrich Böttger, at the time a prisoner of the Saxon duke Augustus the Strong, did discover a formula for porcelain in the year Caetano was hanged. It was, of course, not the promised gold, but the "white gold" saved him, and instead of ending up on the gallows he became the founding administrator of the Meissen porcelain factory. The element phosphorus was

discovered by alchemists, and one of the most important discoveries in the history of the color blue also came from alchemy.

Dippel, the alchemist who was fooled by Caetano, worked in Berlin from 1704 to 1707. He wasn't looking for the philosopher's stone, but for a cure for all diseases, a panacea. And he was convinced he had found the decisive component: "animal oil" derived from a distillation of bones, claws, blood, or flesh. The substance "has a most revolting smell," as *Meyers* encyclopedia notes, and it was already known in Dippel's time. But Dippel combined the oil with potash, distilled it, and then, by repeating the process several times, obtained a particularly pure substance. If one believes contemporary sources (one should not), "Dippel's animal oil" helped to relieve hysteria, convulsions, and fever, as well as typhoid and parasitic worm infections.

At the same time as Caetano was up to his tricks in Berlin, a man called Johann Jacob Diesbach came to work in Dippel's laboratory. Not much is known about Diesbach, but what is clear is that he was Swiss and, among other things, produced pigments and dyes in Dippel's laboratory.

The earliest description of what happened there comes from the chemist Georg Ernst Stahl, who wrote the story down in 1731. According to Stahl, Diesbach was trying to make the red pigment carmine, for which he had to dry tens of thousands of cochineals—little scaled insects—before boiling them and then treating them with alum and potash. Since Diesbach had run out of potash, he used a batch that Dippel had already used for his animal oil. To his surprise, what was left at the end of the process was not red carmine but a deep-blue substance. Dippel had discovered a new pigment: Prussian blue.

THAT'S WHY THE WORLD IS COLORFUL

Subramanian's office is at the end of a corridor on the second floor of the chemistry building. The office is crammed full of books, samples of blue pigments, and wire models of crystal structures. Ask Subramanian why Prussian blue or YInMin blue are blue, and he will take one of these models and describe the arrangement of the atoms. In order to understand blue, we have to plunge deep into the structure of matter.

We say that everything is made of atoms and molecules, and what we mostly imagine are tiny billiard balls that, tightly packed, create a tabletop or a steel girder. In reality, the world, if we zoom in on it close enough, is more like the universe, with huge distances between accumulations of matter. A tabletop consists—and this will never cease to amaze me—largely of nothing. And all of the atoms and molecules that make up the matter around us are constantly interacting with the electromagnetic radiation that penetrates everything: from X-rays to visible light to microwaves and radio waves.

Every wavelength of these waves brings energy with it, and when the waves hit matter, different things happen depending on how much energy that is.

With somewhat longer wavelengths, in the infrared region, molecules and atoms are mostly stimulated to vibrate. The energy of infrared rays is sufficient to give the elementary particles a shove, and we perceive these vibrations—if at all—as warmth. At the other end of the spectrum, in the ultraviolet range, the rays possess so much energy that they can bring about fundamental changes in the structure of molecules. This is why UV radiation can alter the DNA in our cells and cause cancer.

In the visible spectrum, which lies between these two regions, light possesses just enough energy to stimulate electrons, the negatively charged elementary particles surrounding the atom's

nucleus. When that happens, a specific amount of energy is taken on by an electron—that is, a certain wavelength of light is absorbed—and the light that is reflected back, which reaches the eye, is missing this wavelength, so it is no longer white. That's why the world is colorful.

Basically, this happens in two ways. On the one hand, electrons can be sitting on various energy levels. Just as a person can stand on only one rung of a ladder or another, but not between them, electrons can only exist on certain energy levels. Depending on which atom is involved and which atoms surround it, different amounts of energy are needed to raise an electron from one level to the next. The distances between the rungs vary.

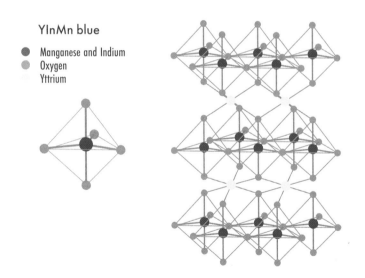

YInMn blue

● Manganese and Indium
 Oxygen
 Yttrium

When light falls on matter, each electron can absorb the specific amount of energy it needs to reach the next energy level. In the case of YInMn blue, a manganese electron is stimulated by

red light and moves to the next level. The red light "disappears," and that is why YInMn is blue. In the case of Egyptian blue, an electron in the copper atom absorbs the red light.

It is possible for electrons to move in another way, too. They can jump from one atom to another—that is, to continue our image, from one rung of the ladder to the same rung of a neighboring ladder. In a sense, they are then jumping sideways, not up. And it is here that the secret of Prussian blue lies.

Seen in chemical terms, the pigment that Diesbach accidentally produced is a cube-shaped grid of carbon, nitrogen, and iron atoms. The carbon and nitrogen atoms will play a cruel role later in the history of humanity. But it is the iron that plays the decisive role for the color. It occurs in Prussian blue in two different forms: as bivalent iron and trivalent iron. The difference is that bivalent iron has one electron more than trivalent iron.

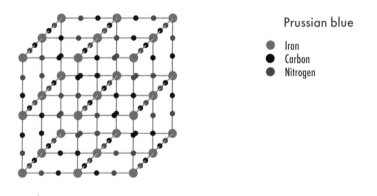

Prussian blue

- Iron
- Carbon
- Nitrogen

So if the bivalent iron's electron gets a little energy boost, it can move into the other iron atom, where the equivalent energy level isn't occupied (because the corresponding electron is missing). The energy needed to undertake that shift corresponds precisely to the energy of light in the red-orange range.

As a result, that range of light is absorbed, and the remainder is reflected and appears to us as blue.

Dippel and Diesbach couldn't know any of that. But when they saw the blue pigment, two things quickly became clear to them: The blue had been formed because the potash had been contaminated with animal blood, and they had made a discovery that could make them rich. Because the pigment was stable, and it was cheap.

Soon, Diesbach and Dippel started selling the pigment. As early as 1709, the Dutch painter Pieter van der Werff painted both the sky and Mary's veil with Prussian blue in his piece *The Entombment of Christ*. In 1724, the Royal Society of London published the formula, which had up until then remained secret, and the use of Prussian blue became even more widespread. Soon artists all over the world were using the pigment. Turner, Gainsborough, and Delacroix used it. We also owe the swirling blue in Van Gogh's *Starry Night* and the works of Picasso's Blue Period to Prussian blue.

"What are all the cornflowers in the world compared with a Prussian blue factory?" the husband asks in Fontane's *Frau Jenny Treibel*. In the novel, the family runs several factories that produce Prussian blue. The pigment even reached Japan, which at the time had shut itself off from the world outside: Hokusai's print *Under the Wave off Kanagawa* owes its radiant blue to Diesbach's bungling of a recipe for red.

THE PRINCE OF CHANCE

Mas Subramanian's discovery was also a matter of chance. He was actually looking for something like the modern equivalent of the philosopher's stone: a multiferroic, a substance that has

certain electrical and magnetic characteristics and that would, for example, enable the construction of new, more efficient computers. "That is something like the holy grail of materials research," Subramanian says. "Everyone would be happy to have a substance like that, but no one knows how to go about it." Subramanian had an idea: a mixture of yttrium oxide, indium oxide, and manganese oxide just might have the desired characteristics. But when his research student Andrew Smith prepared the substance, it had no exceptional characteristics. It was just very blue.

At first Subramanian thought something had gone wrong, but when he and his colleagues repeated the experiment, the result was the same: blue powder. It was then that Subramanian remembered a colleague at DuPont complaining about how difficult it was to manufacture a good blue pigment.

English, unlike German, my mother tongue, has the perfect word for such fortunate discoveries: *serendipity*. The notion was first articulated by Horace Walpole more than 250 years ago. He had read the Persian story "The Three Princes of Serendip." In Serendip, today's Sri Lanka, the princes make innumerable chance discoveries. In a letter, Walpole described to a friend how the three learned that a camel, blind in one eye, had recently traveled the same route as them. The princes had noticed that the grass on the left-hand side of the road had been devoured, even though the grass on the right had been much better. "Now do you understand *Serendipity*?" Walpole asked his friend—thus coining the word for the chance discovery of something you were not even looking for.

It is, however, no accident that accidents have played such an important role in the history of colors. The reason? So far it has been nearly impossible to predict with any certainty what color a particular substance will have without making it.

When Subramanian wants to explain why that is, he doesn't begin with blue, but with ruby red and emerald green. Rubies

and emeralds are two of the classic gemstones. Their colors could hardly be more different, but they come from the same element: chromium. In both gemstones, sprinkled here and there in a grid of other atoms are chromium ions: chromium atoms that have each lost three electrons. One of the remaining electrons, however, can be stimulated by visible light and raised to a higher energy level.

Why, though, does chromium generate a rich green in one case, and a luminous red in the other? The answer lies in the atoms surrounding the chromium ion—its immediate neighbors in the crystal. They influence the amount of energy that is needed for an electron to shift.

In a ruby, the electrons need slightly more energy. That's why more light in the blue-green range is absorbed and the red color appears. In an emerald, the chromium ions need less energy, and what they absorb is closer to the red end of the visible spectrum, which means the color that reaches the eye is green. These differences are tiny, and they are determined by the precise arrangement of the atoms surrounding the chromium. That arrangement can hardly be predicted, Subramanian says. "If rubies and emeralds didn't exist in nature, we would have no idea how to produce them." That is why new pigments are very difficult to plan, and why Dippel and Subramanian are true princes of chance.

But the history of science is not just a story of happy coincidences; it's also a tale of dreadful failures and horrible crimes. The history of Prussian blue doesn't end with the wonderful swirls of Van Gogh's starry sky. What followed was a particularly terrible form of alchemy. Out of the pigment that rendered Hokusai's sea blue, a cruel poison emerged that would immerse a whole generation in death.

BLUE ACID

The French chemist Pierre-Joseph Macquer was interested in pigments, and especially in the blue that had come from Berlin and conquered the world. During his attempt to understand the composition of Prussian blue in the middle of the eighteenth century, Macquer succeeded in breaking down the pigment into two components—an iron salt and an as-then-unknown acid that, because of its origin, became known as prussic acid: hydrogen cyanide.

This acid is highly poisonous. The cyanide ion, a simple compound of one carbon and one nitrogen molecule, binds to an iron atom in human cells that plays a decisive role in cellular respiration. Once that iron atom has been bound, oxygen from the blood can no longer be used by the cells. The person suffocates internally, even though their blood is full of oxygen (which is why a blue discoloration of the skin, typical in asphyxiations, does not appear).

It's a cruel death. High doses of the poison "quickly lead to death," the authors of the German book *Schädliche Gase* ("Harmful gases") noted in 1931, "with a violent sense of constriction, often associated with screaming [. . .] it results in a sudden collapse; convulsions ensue and after a few minutes breathing ceases and death occurs after 6–8 minutes."

The substance aroused people's morbid curiosity, and the smell of bitter almonds became a cliché of crime novels. No poison is used more often in Agatha Christie's novels (one is even titled *Sparkling Cyanide*).

But its use was not restricted to fiction. In the First World War, France used the gas, even though it dissipated too fast to be an effective weapon. From 1924 on, it was employed in the United States to execute people condemned to death in the gas chamber. In Germany it was developed into Zyklon B, the

poison Nazis used to carry out mass murder in the extermination camps.

Ultimately, many of those who had planned and carried out the Holocaust died by cyanide poisoning themselves: Heinrich Himmler, Hermann Göring, Martin Bormann, Richard Glücks, and countless other Nazis killed themselves with cyanide capsules filled with minuscule amounts of the same poison that had been employed by the ton in Auschwitz. "Death is a master from Germany, his eye is blue," Paul Celan wrote in his poem "Death Fugue."

BLUE MEDICINE

On September 13, 1987, Roberto dos Santos Alves and Wagner Mota Pereira broke into an abandoned clinic in the Brazilian town of Goiânia. Behind an armored door they found an apparatus that looked valuable. They took it away and sold it five days later to the scrap merchant Devair Alves Ferreira.

Ferreira took the device apart and found a material inside that had a beautiful blue glow. He took it home, gave some of it to friends, and planned to use the rest to make a bracelet for his wife. He sold what was left of the machine.

Then the people around Ferreira, his family and friends, began to get sick. Two weeks later, Ferreira's wife went to the hospital. Only at this point did it become clear that Alves and Pereira had set off a catastrophic chain of events. The apparatus they had stolen had been used to treat people with cancer, and the radiant blue material was cesium chloride, a highly radioactive substance. By that time it had contaminated large parts of the town.

During the next few weeks more than a hundred thousand people were examined for radiation poisoning. Dozens became

seriously ill. Ferreira survived, but his wife, his niece, and two of his assistants died from the exposure. Many buildings had to be painstakingly decontaminated, some were torn down.

Fortunately there was medication available for the people who had inhaled the cesium chloride or ingested it with their food: Prussian blue. The pigment binds the cesium in the intestine, which prevents it from being absorbed into the body. That is why the World Health Organization put Prussian blue on its list of essential medicines in 1990. A stockpile was established in the United States after the terrorist attacks of September 11, 2001.

Prussian blue is not the universal remedy Dippel was searching for. But the pigment that came about through a mishap in his lab is a remarkable substance that has, over the centuries, played a role across the entire spectrum of human activity, from mass murder to medicine.

COLD, CLEAR WATER

The first artist to use Subramanian's blue was his wife. Rajeevi Subramanian is a chemist as well, but she is also an enthusiastic painter—and she had the perfect subject for the radiant new blue right on her doorstep, so to speak.

Corvallis, Oregon, is situated halfway between the Pacific Ocean and the Cascades, a mountain range stretching along the western coast of the United States from Canada to California. It is part of the Ring of Fire, a belt of volcanoes surrounding the Pacific to the north, east, and west. One of these volcanoes, Mount Mazama, lies around 200 miles (300 km) to the south of Corvallis. Around 7,700 years ago, Mount Mazama exploded in an immense eruption, the biggest in that chain of volcanoes

in a million years. The Klamath Indians, who still live there today, describe what happened as a battle of the gods. A gigantic amount of volcanic ash was emitted, enough to bury the whole state of Oregon under a layer 8 inches (20 cm) thick, as an information sheet from the National Park Service proudly explains. The mountain collapsed in on itself, shrinking by roughly 4,900 feet (1,500 m). Its summit was replaced with a deep crater, which filled with water over the following years.

Today, at about 1,950 feet (590 m) deep, Crater Lake is the deepest lake in the United States. And it is one of the clearest lakes in the world, fed solely by snow and rain. Hardly any algae grow in the cold lake.

Crater Lake is famous above all for its color. When the geologist Clarence Dutton studied the lake in 1886, he described his impression: "As the visitor reaches the brink of the cliff, he suddenly sees below him an expanse of ultramarine blue of a richness and intensity which he has probably never seen before, and will not be likely to see again."

When I drive to Crater Lake with Rajeevi Subramanian and her husband, this remarkable blue can be seen only here and there. Rajeevi points to a corner of the lake she painted a few years ago, and, indeed, the water there gleams with an impressive blue. But on that day, unfortunately, smoke from nearby forest fires is hanging in the air, and the sun simply refuses to appear. The lake lies there, still and beautiful and blue, but lacking the dramatic element that the poet Alexander Theroux describes in his essay on the color blue: It is "the bluest blue lake in the world," he writes; its color, "almost intolerable in its beauty, can swamp with emotion the flickering power of analysis."

In one respect, Theroux is absolutely right. The question of why water appears blue has led many thinkers astray. Some have claimed that light is dispersed in water, just as in the sky (in fact, Theroux himself writes this). Others contend that the sky

is simply reflected in the water. But it is actually the nature of the water molecule itself that gives water its color. And if the molecule wasn't like this, life on Earth as we know it might not be possible.

Water is an exception. As far as we know, it is the only substance on Earth whose color doesn't depend on the movement of electrons but on the vibrations of molecules. Normally the energy of infrared light is enough to make molecules vibrate, but the water molecule is a special case.

A water molecule consists of a central oxygen atom and two hydrogen atoms arranged so that the model of the molecule resembles the letter *V*. These two hydrogen atoms (the lightest atoms there are) are bonded especially firmly in water. That increases the energy needed to set them vibrating. When sunlight hits the water, it is not the low-energy infrared light that induces the movements, but visible light in the red range. So the water absorbs this part of the light and transforms it into motion. The rest of the visible light remains and appears blue. In a glass of water, the effect is too weak to be seen. But in deep, clear water one can see it incredibly well, and that is why Crater Lake is so remarkably blue in the sunshine.

But why is that the case? One peculiarity of the water molecule is that it has a positive and a negative pole. The oxygen atom shares two electrons with each of the hydrogen atoms. But these negatively charged particles are not sitting halfway between the hydrogen and the oxygen. The oxygen pulls them in its direction more strongly than the hydrogen does, and that gives rise to a negatively charged part of the molecule. The hydrogen atoms, on the other hand, have a slight positive charge. This charge makes water molecules stick to each other more strongly than would normally be the case; scientists call these hydrogen bonds. They are the reason why water is still liquid at room

temperature and only becomes a gas at 212°F (100°C)—one of the requirements for life as we know it. They are also the reason why sugar dissolves in water. And, if one believes many scientists, they are the reason why water is blue—for the firm bond, they say, increases the amount of energy needed to set the molecules vibrating.

THE ART IN ARTIFICIAL

Before YInMn blue amazed the world, ultramarine was the measure of all (blue) things. "Hardly any other color had created such a stir, such interest and chemical investigations of its component parts and formation as ultramarine," the chemist Christian P. Pruckner wrote in 1844.

As far back as the seventeenth century humans were trying to manufacture ultramarine artificially. But as late as the beginning of the nineteenth century, it still wasn't clear what the blue powder consisted of. Scientists believed the color must derive from a metal, most likely iron, as was the case with Prussian blue. And an analysis of lapis lazuli had shown that the stone did contain iron. But when people took the trouble to manufacture ultramarine from lapis lazuli and then analyze it, they established that there was no iron left in the final pigment. It did, however, contain sulfur.

Today it is clear that sulfur is indeed the key to ultramarine blue. The atoms of lazurite form tiny cages in which trisulfide anions—compounds of three sulfur atoms that together have one surplus electron—are captured. The extra electron can be prompted by red light to move from one sulfur atom to the next. It is the same mechanism that gives Prussian blue its color, only in this case, the crucial atom is sulfur instead of iron. The same

sulfur that in its pure form gave off such a yellow glow in my collection of minerals is the reason that lapis lazuli is blue.

In 1823, the Prussian Association for the Encouragement of Industriousness promised a prize of a gold medal and one hundred thalers for a blue color "of sufficient beauty, power and richness to replace ultramarine." Two years later the prize was raised to two hundred thalers. In France, the Société d'Encouragement pour l'Industrie Nationale offered a prize of six thousand francs for "the discovery of a cheap method for the preparation of an artificial ultramarine which is completely similar to that derived from bluestone and which could be produced at 300 francs per pound."

Two people demanded the money at the same time: the German scientist Christian Gottlob Gmelin and Jean-Baptiste Guimet, a Frenchman. They had almost simultaneously developed a process for producing artificial ultramarine, and both wanted to collect the prize money. The honor eventually went to Guimet, who was the first to develop the process on an industrial scale. He soon had a flourishing business in the form of an ultramarine factory outside Lyon. Others followed him. The druggist Carl Leverkus improved upon Guimet's process and was granted a patent for Prussia. When he transferred his ultramarine factory to the Rhine, a town quickly grew up around it: Leverkusen. In the 1870s more than thirty firms were producing a total of 22 million pounds (10 million kg) of artificial ultramarine per year.

Once worth its weight in gold and reserved for the finest of fine art, ultramarine had become a mass-produced commodity. Housewives added it to the final wash cycle to make dull laundry dazzling white again. The pigment was even added to sugar to make it appear whiter. (Blue is yellow's complementary color, so yellowish things look whiter when a little blue is added to them.)

In the Middle Ages, ultramarine was made from lapis lazuli in a time-consuming and costly process. The pigment was more valuable than gold.

And yet this "most perfect of all colors" still didn't lose its attraction. On the contrary. In the twentieth century, artificial ultramarine became the basis of what may be the most famous blue in the world of art: International Klein Blue, or IKB.

The French artist Yves Klein was fascinated by blue from a very early age. Even as a teenager lying on the beach in Nice, he had signed the blue sky as his own artwork. "I have hated birds ever since for trying to make holes in my greatest and most beautiful work," he wrote.

He later transferred the blue of the sky into his studio and painted the blue hue on huge canvases. The power of these monochromatic masterpieces cannot be conveyed in photographs. When I stood in front of one of these paintings for the first time in Paris, its impact—the punch of the blue, its velvety quality—left me speechless.

"All colors bring forth associations of concrete, material and tangible ideas, while blue evokes all the more the sea and the sky, which is most abstract in tangible visible nature," Klein wrote. His friend, the critic Pierre Restany, calls blue "the physical sign of the infinite in its immensity." And that may be what is most fascinating about Klein's oeuvre: It appears to give body to the unfathomable blue of the sky and the sea so that we can grasp it, maybe even in both senses of the word.

Klein was complicated—a mystic and a materialist, possessing an artistic sensibility and a black belt in judo. Conservative and provocative in equal measures, he was a performance artist before such a thing even existed. In one of his productions an orchestra played the same note for twenty minutes while naked women covered themselves with International Klein Blue before an indignant public and then rolled themselves over white canvases.

That Klein's art remains famous even today is down to chemistry as much as charisma. The blue chosen by Klein was the blue from the stones, ultramarine, the "mineral blue par excellence," in Restany's words. His decisive trick was combining the synthetic pigment with a new binding agent. In order to create a paint, ultramarine is mostly dissolved in oil, but that makes the blue duller and grayer. Together with Édouard Adam, a Parisian dealer in artists' materials, Klein discovered a binding agent that could retain the splendor of the pigment: Rhodopas M60A. Even today, anyone who wants to can buy everything needed to make IKB—only it can't be called IKB. Yves Klein registered the process with the Paris patent office in 1960.

The sulfur that gives ultramarine its color was also the reason for the pigment's decline. Producing ultramarine releases tons of sulfur compounds into the atmosphere: These are very harmful to the environment, and many countries have ceased making the color as a result. Could there be a successor to ultramarine

in the twenty-first century, one that would finally eclipse it? What could the next blue be? I followed the trail of YInMn blue one last time. It took me to London again.

THE DEEPEST BLUE

In the spring of 2018, a sample of YInMn blue came to University College London. When the scientist David Dobson saw how excited some of his colleagues in the art department were, he was baffled: "I thought, *Hang on a minute, I'm making blue all the time in my lab.*"

Dobson is a geologist. He is interested in the way Earth is formed internally, and that can hardly be investigated directly. "The deepest mine in the world goes down 2.5 miles (4 km), the deepest borehole 8 miles (13 km), and the center of Earth is 4,000 miles (6,500 km) down," he tells me when I go to see him in London. That is why scientists such as Dobson have to examine the interior of Earth indirectly—by re-creating the conditions prevailing down there in the lab.

Above all, Dobson is studying the transition zone between the upper and the lower mantle, about 310 miles (500 km) beneath our feet. The pressure at that depth is two hundred thousand times greater than the pressure on the surface of Earth. Dobson can create this pressure in the university basement with a machine called a multi-anvil cell. If he puts the most abundant elements of the earth's mantle into the press, a mineral called ringwoodite is formed. It makes up about 80 percent of the transition zone. It's an important object of Dobson's studies. And it just so happens to be a deep, luminous blue.

In Dobson's lab I examine a tiny piece of ringwoodite through a microscope. The piece is only a few micrometers in size, but it

has a powerful deep-blue color. As with Prussian blue, the color is caused by bivalent and trivalent atoms of iron pushing electrons to and fro.

Having seen the success of YInMn blue, Dobson decided to try to turn his deep-Earth blue into a new pigment. There was just one problem: Ringwoodite isn't stable on the surface of Earth.

The high pressure in Earth's interior compresses different elements to different degrees, so that the same atoms arrange themselves in a crystal grid different from what they would form on the surface of Earth. Every iron atom in ringwoodite is surrounded by four oxygen atoms sitting on the corners of a three-sided pyramid. It just so happens that it takes precisely the amount of energy contained in red light for the electrons to jump from iron to iron, with the result that the mineral appears blue.

But this arrangement of atoms, which is most stable in Earth's interior, is no longer so on the surface of Earth. The ringwoodite that Dobson creates in his lab does retain its shape, but only a small amount of energy is enough to destroy its structure. Scientists say that on the surface of Earth, ringwoodite is "metastable." You can imagine it like Wile E. Coyote, the coyote from the old cartoons, running over the edge of a cliff and staying suspended in the air for a moment. Even the energy created by grinding the mineral would be enough to ruin it. Just as the coyote looks down and then inevitably falls, the mineral's crystal structure would change, and it would lose its color.

Dobson's aim is to re-create the atomic structure of ringwoodite in a way that is stable on the surface of Earth: a crystal shape in which bi- and trivalent iron atoms are surrounded by a pyramid of four atoms. That is no easy undertaking—iron arranges itself differently on the surface of Earth. And that is one of the reasons why blue is so rare.

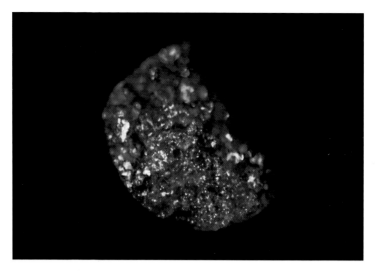

A tiny piece of ringwoodite from David Dobson's laboratory. The mineral occurs in the interior of Earth, but is not stable on its surface.

Other elements, such as cobalt or copper, could have the right characteristics to create blue in crystals, Dobson says. But those elements are rare. Iron, on the other hand, is one of the most abundant elements in Earth's crust, where it mostly gives rise to red, yellow, and brown hues (like rust). That's why those colors were the first ones our ancestors had access to.

And why is it that iron, of all elements, is so common? Ultimately the answer lies in the stars.

In our Sun, hydrogen atoms melt and are fused into helium. We owe the fact that there is any life at all on Earth (and any light to see by) to the energy released in that process. Once the hydrogen has been used up, helium nuclei fuse into carbon; then into oxygen, magnesium, silicon (depending on the size of the star). But when iron begins to be made, it's all over.

Fusing small atomic nuclei releases energy (which happens in stars), and splitting large atomic nuclei also releases energy

(which happens in nuclear power plants). In a way, iron marks a turning point. Combining iron atoms to make heavier elements does not yield any more energy. If a star reaches that point, it dies, and only in the massive explosion of a supernova are heavier atoms forged. So iron is the ash of a burning star, and it is out of those ashes that planets such as Earth eventually arose.

Should Dobson have success with his project, it would be the first time humans have deliberately made iron into a specific form to create blue. And ringwoodite would pave the way to a new blue. But if he fails, this beautiful irony will remain: While we've been up here on the planet's surface, doing everything we can for thousands of years to produce new blue pigments from Earth's minerals, there is—below our feet, unimaginable and inaccessible—a gigantic reservoir of blue stone.

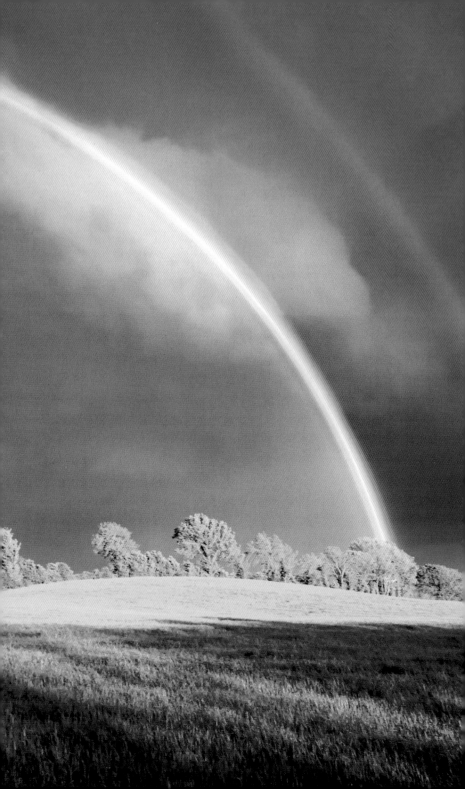

SEEING

I see skies of blue . . .

—LOUIS ARMSTRONG

A rainbow is formed when sunlight is scattered and reflected in raindrops. Light that is twice reflected forms a second, weaker rainbow—with a reversed sequence of colors—above the first one.

One of my favorite scenes in *The Simpsons* is a brief sequence in which Homer Simpson is riding in a car with his boss, Montgomery Burns, the millionaire owner of a nuclear power plant. Burns is envious of a new millionaire in town who's capturing people's attention. "I'm not easily impressed," Homer says. Then he glances out of the window. "Whoa, a blue car."

We laugh at Homer and how easily he's distracted. But sometimes I think he's ahead of us in certain ways. Every day we walk through this world of thousands of colors. But we're so accustomed to it that we're hardly aware of that vivid wonder. If we see a really beautiful cornflower at the edge of a field, it might make us pause for a moment. But really, even the sight of a blue car ought to amaze us, for creating the perception of blue demands a complex choreography of light, eyes, and brain.

Even when we take the time to think about it, our intuition obscures what a crazy phenomenon colors are. We see the cornflower. We see blue. And for us, the blue of the cornflower is a part of that flower. But we have it backward. The cornflower absorbs the red part of the sunlight that falls on it and reflects the rest, which appears blue. So in a sense, blue is what the plant rejects. Calling it "blue" is a bit like calling a country club "feminist" because it doesn't allow women. No wonder, then, that

many of the scientists I've spoken to don't talk about blue pigments, but about "red-absorbing" ones.

And that's just the beginning.

In the midday sun, the cornflower reflects a light that's quite different from the light at twilight, and yet to us it looks equally blue throughout the day. How can that be?

One reason for the confusion is that the processing of visual information in our brains is not conscious. We have the feeling that we are looking immediately and directly into the blue. Our mind is transparent, philosophers say. We simply see "the blue" with no awareness of the process of seeing itself.

"Look at the blue of the sky and say to yourself 'How blue the sky is!' When you do it spontaneously—without philosophical intentions—the idea never crosses your mind that this impression of color belongs only to *you*," the philosopher Ludwig Wittgenstein wrote. "And if you point at anything as you say the words you point at the sky." Shouldn't we really be pointing at ourselves? Why do we see a color such as blue at all? Do we all see the same thing? Does "blue" exist at all? And if it doesn't, why the hell am I writing a whole book about it?

INVISIBLE RAINBOW

When I was in elementary school, I learned a secret from television: When a rainbow appears in the sky, you can often spy a second, weaker rainbow above it, the colors reversed. A rainbow occurs when the light in the raindrops is reflected and refracted. The second rainbow is formed by light that is reflected for a second time on the inside of the drop before emerging. I was awestruck by this, and when I see a rainbow today, I still look in the sky above it for its fainter reversed image.

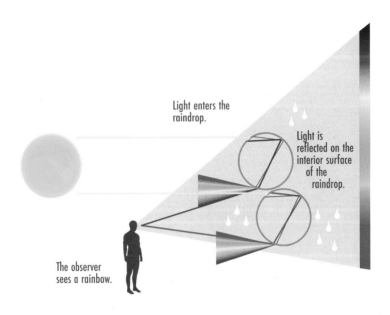

Light enters the raindrop.

Light is reflected on the interior surface of the raindrop.

The observer sees a rainbow.

To me, one of the marvels of science is that it can let us see what is hidden, it can make the invisible visible. This becomes especially obvious when discussing the basis of vision itself: light.

The story begins in England in 1666. It was a terrible year for the city of London, which was ravaged first by the Great Plague and then by the Great Fire. But for the physicist Isaac Newton, it was an annus mirabilis. While the University of Cambridge was closed because of the plague, Newton carried out experiments in his home village of Woolsthorpe-by-Colsterworth (try saying that as a German).

There, Newton made decisive discoveries about gravity, mathematics, and mechanics, and also about light. At the time, most scientists believed that colors came from the combination of varying degrees of light and darkness. But with a prism,

Newton showed that he could separate sunlight into the colors of the rainbow and then put them back together to make white light. What had previously been simply "white light" was suddenly a spectrum of color. Newton divided it up into seven colors: red, orange, yellow, green, blue, indigo, and violet.

Newton probably added indigo just to get to seven colors. The scientific genius was also a mystic, and to him the number seven seemed more in harmony with the universe (at that time seven planets were known, and the seven notes of the musical scale had mystical significance). Today the color indigo has disappeared from many representations of the rainbow, and the number of colors has been reduced to six: Just have a look at the cover of the Pink Floyd album *Dark Side of the Moon* or the rainbow flag.

At the same time, however, scientists have extended the rainbow by countless "colors." In 1800 the astronomer William Herschel was trying to measure how warm the various colors in the spectrum are, and, to his surprise, he found that the thermometer showed the highest temperature when he placed it beside the red light, that is, outside the visible spectrum. Clearly there were additional, invisible rays beyond red. Herschel had discovered infrared radiation.

One year later, Johann Wilhelm Ritter proved that there were also rays beyond violet: ultraviolet, or UV, rays. Over the next hundred years, radio waves, X-rays, and gamma rays were added.

Newton's successors kept on extending the spectrum of electromagnetic waves. Today, visible light accounts for only a tiny part of a much bigger "invisible rainbow."

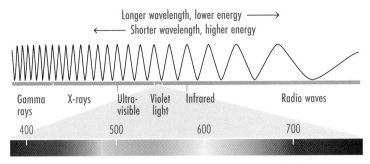

Longer wavelength, lower energy ⟶
⟵ Shorter wavelength, higher energy

| Gamma rays | X-rays | Ultra-visible | Violet light | Infrared | Radio waves |

400 500 600 700

Wavelength in nanometers

I still find it fascinating and difficult to understand that the Sun's rays of light are ultimately waves, like those carrying a radio program or the rays that warm up my food in the microwave. They differ only in wavelength, and therefore in energy. The shorter the wavelength, the more energy the waves carry. The only thing that is special about light waves is that we can see them.

Newton's explanation of the rainbow did not wow everyone. The British poet John Keats was anything but pleased with the physics. "There was an awful rainbow once in heaven: / We know her woof, her texture, she is given / In the dull catalogue of common things," he wrote in his poem "Lamia." By measuring the rainbow, Keats felt that Newton had robbed it of beauty: "Do not all charms fly / At the mere touch of cold philosophy?"

It's an absurd accusation, if you give it a little thought. As if a wine buff would value a Bordeaux less, the more he knew about the many steps needed before the fine wine ends up in his glass.

The rainbow appears not one bit less colorful, its colors not one bit less brilliant because we now know how this spectacle comes about. On the contrary: Suddenly we can see in the rain

thousands of prisms falling from the sky; we can see the unfolding of the sunlight in the colors, in their sequence the cosmic order of the wavelengths; and we can sense further invisible stripes above the red and below the violet.

And that is just the rainbow. How fascinating is vision itself! I dare anyone not to be amazed when retracing even roughly how physics, physiology, and psychology interact to allow us to see colors and, for example, trigger the sense of "blue" in our minds.

And it all starts 93 million miles (150 million km) away from Earth.

THE LIGHT THAT GOT LOST

Eight minutes. That's how long it takes for light from the Sun to reach Earth. It races through the cold vastness of the universe at a speed of 186,000 miles (300,000 km) per second. And it's not alone. Inside the Sun, hydrogen atoms are fusing into helium atoms, releasing huge amounts of energy. At 6,000 Kelvin, the surface of our star radiates everything the electromagnetic spectrum has to offer, from tiny microwaves to radio waves several meters in length. Eight minutes. Then they all hit Earth's atmosphere together. For a large part of the spectrum, the journey ends there. Shortwave and long-wave X-rays and long-wave radio waves are largely reflected back into outer space. Infrared radiation doesn't get through the atmosphere either. It is absorbed by the gas molecules of the air.

But radiation with a wavelength of around 430 to 690 nanometers, the range that humans perceive as white light, manages to pass through the atmosphere almost unfiltered. Scientists call this the "optical window." It is the window through which we see the world.

However, the light in this range does not reach Earth's surface all at once—nitrogen and oxygen molecules diffract the shortwave blue and violet light to a greater extent, so that the rays that leave the Sun as white light reach us with some of their blue portion missing. That's why the Sun looks yellow. And the sky is blue for us because that diffracted blue light is scattered across the sky and reaches us from all directions. Physicists talk of "stray light." The American writer Rebecca Solnit calls it "the light that got lost."

To be precise, only a small portion of the blue light is scattered across the sky. And the light that is most readily dispersed has wavelengths that are even shorter than violet light. This light falls in the ultraviolet range. So we are surrounded by UV light, which is why you can get a sunburn even in the shade.

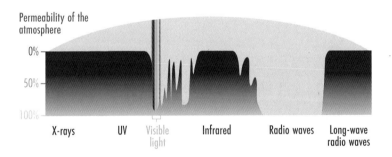

Permeability of the atmosphere

0%

50%

100%

X-rays UV Visible light Infrared Radio waves Long-wave radio waves

Once it arrives on Earth's surface, the sunlight finally falls on a cornflower at the edge of a field. Part of the red light is absorbed by the blossom, and the rest is reflected. This light, which contains the whole spectrum of visible light apart from the red portion, then hits the cornea of our eye, where it is

refracted; passes through the pupil, the circular opening of the iris; hits the lens, where it is further focused; passes through the vitreous body, a kind of transparent gel filling most of the eyeball; hits the retina; and is finally absorbed by a layer of cells containing the pigment melanin.

Eight minutes after the light has left the Sun, it is extinguished in our eye. But before the light ends its journey on the retinal pigment epithelium, another part of it is lost. In the photosensory cells of our retina, it hits a tiny molecule that reacts by changing its form slightly. It's like knocking over the first domino. And it is how the process of seeing begins.

EYE-ANIMALS

An ugly concrete building at the Frankfurt am Main University clinic is one of the first places I go in my quest to understand the beauty of blue. There, at the end of a gray linoleum corridor, Leo Peichl has a small office, the shelves and cupboards of which are full of books, papers, and eyes.

Peichl is a friendly old man. He worked for many years at the Max Planck Institute for Brain Research in Frankfurt, researching how mammals see the world. In one of his first emails, he wrote that I should come and see him in Frankfurt: "Then I could show you my eye collection."

Peichl's collection of eyes is housed in a refrigerator as tall as he is, which stands by the entrance to his office. The eyes of bears, foxes, and sea lions are in there, swimming in formalin. Hundreds of other eyes are stored in little cardboard boxes: bats' eyes the size of a pinhead, hamsters' eyes, voles' eyes. He has the eyes of tenrecs and tufted-tailed rats from Madagascar. In the door of the fridge are pickle jars filled with elephants'

eyes. In a plastic container that looks as if you should be spooning potato salad from it floats a white lump: the eye of a fin whale—the biggest in Peichl's collection.

Peichl is primarily interested in the sensory cells of the eye, the ones that detect light. He prepares the retina of an animal's eye, colors it with different dyes, and then, in patient, meticulous work under the microscope, he counts the numbers of each different type of cell.

Humans have five senses. But compared to our other sense organs, our eyes are extravagantly equipped. Humans are visual animals. On our tongues we have about a million sensory cells for taste; in the inner ear a few thousand hair cells transpose sound into electrical signals. In contrast, there are about 120 million rod cells in each eye, which perceive weak light at night and in the twilight. During the day, these rods are blinded by the brightness, and we see with about five million cone cells in each eye.

These cells, with which we see colors, are indeed shaped like cones. The membrane of each cone is folded numerous times, and in each fold there are countless molecules of the light-sensitive pigment photopsin. Photopsin has two parts: a large protein molecule called opsin, and a small molecule called retinal, which is bound to the opsin. This little molecule performs the crucial work. When light hits the retinal, the molecule changes its structure slightly. Previously, it had a kink in it; now it has a stretched-out shape. Having undergone this change, the retinal molecule no longer fits into the binding pocket of the opsin, causing the opsin to change its form as well—and that change sets off the next step in the cell, and so on. At the end of this cascade, the cell generates an electrical excitation. The light has become an electrical signal that can be transferred to the brain and processed.

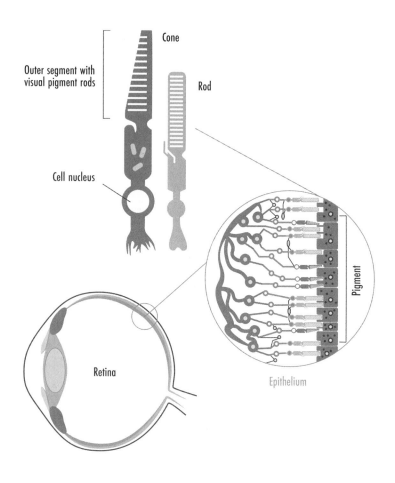

Humans can see colors only because different cones react to light of different wavelengths. Scientists puzzled for a long time over exactly how this might work. Back in 1802, the British physician and physicist Thomas Young had already realized it was unlikely that the retina would have a separate receptor for every wavelength. "It becomes necessary to suppose the

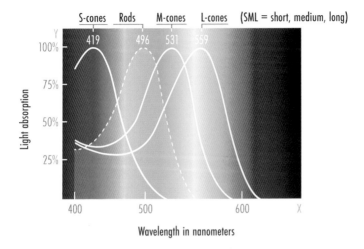

Wavelength in nanometers

number limited, for instance, to the three principal colours, red, yellow and blue," he surmised in a lecture to the Royal Society of London. He was remarkably close to the truth. Fifty years later, Hermann von Helmholtz confirmed in experiments that all colors are indeed blended from three basic colors, though they turned out to be red, blue, and green—not red, blue, and yellow, as Young had assumed.

As a result of Helmholtz's experiments, the three-color theory became widely accepted. Indeed, humans do have three different types of cones. For simplicity's sake these are called the red, green, and blue cones. In reality, however, they react most strongly to yellow-green, emerald-green, and blue-violet light.

Why do the cones react to light of different wavelengths or different colors? The light sensor, the retinal, is always the same molecule, but the opsin, which it is bound to, differs slightly in the three types of cones. The retinal is a little like the chromium ions in the emerald and the ruby that absorb light of different wavelengths because their environments differ somewhat.

Depending on the structure of the opsin, different amounts of energy are needed to alter the shape of the retinal, and so the cones respond to light of varying wavelengths.

The small differences between the opsins allow Peichl and other scientists to stain solely the blue cone-types. If they do that to a human retina, one can see that the cones are not evenly distributed. Blue cones are by far the rarest, around one tenth of all the cones. And at the point of sharpest vision, there are no blue cones at all. Why? It's unclear. But it's another example of blue being especially rare. And the consequence is that humans can hardly make out very small areas of blue. We are all slightly color-blind.

Scientists call this effect small-field tritanopia, the little brother of tritanopia, or blue-yellow color blindness. In this rare form of color blindness, people have no blue cones at all. Since blue cones are rare anyway, such people's visual acuity is hardly reduced. But their perception of color is restricted: For them, the rainbow looks somewhat like the flag of the Netherlands, with a slow transition from red to light blue with a white stripe in between.

People with only two types of cone are considered to have defective vision. But for most mammals, that is quite normal: Their retinas have only blue and green cones. Birds, on the other hand, have four receptors, and reptiles as well. From such differences, scientists can infer the history of color perception in animals and reconstruct the winding paths of evolution.

CONES OF VISION

In the history of life, eyes have arisen independently dozens of times. For vertebrates, the group to which humans belong, color vision probably developed around five hundred million

years ago. At that time, there were four different types of cones: As well as the red, green, and blue cones, these animals had an additional cone that detects light in the ultraviolet region. Most birds, reptiles, and fish still have these four receptors today. They can see a broader spectrum of light than humans can.

Around two hundred million years ago, the first mammals appeared. It was the age of the dinosaurs, and the ancestors of present-day mammals had difficulty holding their ground against the huge reptiles. Evolution found them a survival strategy: Stay out of the way. They remained small, feeding mostly on insects, and, most important, they were active at night. That meant that the cones that are adapted to daylight were of little use to them. Over millions of years, two of the four receptors were lost, clearly without causing any harm to the animals. What remained were the green cone and the UV receptor, whose sensitivity shifted, transforming it into the present-day blue cone.

After the dinosaurs went extinct sixty-five million years ago, new opportunities presented themselves to mammals, and many of them developed a diurnal lifestyle. But they could not recover the cones that their ancestors had lost, and so cats, dogs, and elephants live today with just two cones: one for blue and one for green.

Around thirty million years ago, some mammals acquired a third cone again. In an ancestor of the Old World primates, the gene for the green cone was duplicated by mistake. Over untold generations, minor errors accumulated in the genes for the two receptors, which came to be more and more differentiated until one of them finally became the red cone. That is why Old World apes such as baboons, gibbons, and humans have three different types of cones today.

What survival advantage did the third receptor provide? Scientists have two principal theories about that: Some believe that better color vision helped our ancestors to distinguish ripe red

fruit from green foliage more easily. Others assume that it helped them recognize fresh young leaves, which were an important source of food when there was no ripe fruit. One way or another, we developed our present visual sense so that we could perceive the glorious colors of plants. Think about that the next time you contemplate a cornflower.

And there is more: We depend on plants to be able to see at all. Humans cannot produce retinal themselves; for that we have to ingest the plant pigments beta- and alpha-carotene, the precursors of vitamin A that are converted into the visual pigment retinal, mostly via cells in the intestines. The visual animal needs plants to see. In many parts of the world, however, children don't get enough vitamin A in their food. Because of this, up to half a million children go blind every year, even today.

While our ancestors acquired a third receptor, other mammals lost one of the two they started with. In 1998, Peichl was studying mammals living in the sea. Had they adapted their retinas to the underwater world in any way? He examined countless aspects of the eyes of a common seal. Everything seemed normal. Finally he stained the various types of cones. To his surprise, the animal had no blue cones. It was a strange result: Animals who lived in the blue underwater world could not perceive, of all kinds of light, blue? Peichl examined other marine mammals: fur seals, dolphins, whales. They all lacked the blue cone. Clearly sea mammals have lost the ability to perceive blue light.

It gets even stranger: This must have happened two separate times. At least that is what scientists assume, because seals and whales are not related. The closest relatives of whales are hippopotamuses, while seals are closely related to carnivores like bears or wolves. Hippopotamuses and bears still possess their blue cones, so the two groups of marine mammals must have lost their blue cones independently.

Peichl believes that the ancestors of both groups initially adapted to shallow coastal waters, where the blue receptor was not of much use. "The animals that now live out in the open sea might like to have their blue cones back, but such a mutation is difficult to reverse," Peichl says. Evolution does not work according to some great plan. Often it is two steps forward and one step back. And sometimes it's just two steps back, and that's it.

But what does that mean for the animals? Can blue whales not see any blue? Do birds see more colors than we do? We will probably never have the ability to appreciate exactly what the world looks like through the eyes of a particular animal. But what we know about the cones of the animals allows us to guess at it at least.

BIRD'S-EYE VIEW

Animals that have only one type of cone can presumably see the world only in shades of gray. Why? Because cones of a particular type do not react only to one wavelength. Blue cones, for example, do not absorb blue light alone; they are simply most sensitive to blue light. They are also stimulated by green or violet light, just less intensely. If a cone is stimulated, it doesn't pass on any information about the wavelength of the light to the brain, only the signal that it has been stimulated and how strongly. If a blue cone sends a weak signal, the brain cannot decide: Was the cone stimulated by weak blue light or by strong green light, to which the cone is just less sensitive?

That is precisely what happens to people at night. The visual pigment in the cone reacts most strongly to green light. "Despite that, all cats are not green in the dark, but gray," Peichl says. So

blue whales cannot just see no blue: They see everything gray-on-gray. And the same is true of other sea mammals. The only mammals in the sea that can enjoy the splendor of color in a coral reef are probably snorkeling humans.

Animals that have two different cones can compare the two signals with each other, and that allows them to see a spectrum. Scientists have shown that dogs can distinguish colors on a spectrum of blue to yellow, for instance.

The world of birds, on the other hand, must be a riot of color. Since they can perceive not only the light that is visible to humans but also UV light, they have access to a broader spectrum.

These differences are of immense importance for biologists.

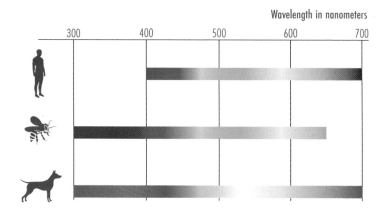

Wavelength in nanometers

To understand colors in nature, they have to stop looking at the world with human eyes and instead take a bird's- or a bee's-eye view. After all, the blue of a cornflower or a blue tit is not

intended for humans. For every color in nature, one must ask: Who is it intended for, and what exactly does that animal see?

Many insects, bees for example, do have three types of cones, like humans, but their receptors are shifted into the shortwave range. They have, roughly, one receptor for UV, one for blue, and one for green. This arrangement seems to be older than the first flowering plants, and is one reason why blue plants are pollinated more often by insects and red ones by birds. In fact, many plants have patterns in the UV range that humans cannot perceive with the naked eye.

The same is true of animals. We see a blue cap and call the bird a blue tit. But what does the blue tit look like to other members of the same species? The blue cap does not reflect blue light alone, but—invisible to humans—just as much UV light. If blue tits could give themselves a name, they might call themselves UV tits.

In fact, humans could, in theory, perceive UV light. The sensitivity of our blue cone does extend to ultraviolet, but only weakly. The reason we do not perceive this light is because the lens of our eye blocks UV rays, presumably to protect the tissue. When artificial lenses were first implanted in patients to treat cataracts, these lenses let in UV light. After surgery, these people could perceive a little UV light. However, they didn't see it as a separate color, but as a shade of blue. Today, artificial lenses usually come with a UV filter.

THE COLOR OF DISTANCE

Different colors evoke different associations in humans. Red is seen as aggressive and exciting, green as gentle and natural. Ask

people what they think when they see blue, and one word that is likely to come up is *distant*.

Goethe described that in his *Theory of Colours*: "As we see the high heavens and the distant mountains as blue, then a blue surface seems to recede before us," he wrote. "Just as we like to pursue a pleasant object that is fleeing from us, we like to see blue not because it presses itself on us but because it draws us to it."

Can the physics of light and the physiology of the eye help us to understand this effect? They can, at least a bit.

Distant mountains appear blue because the layers of air between us and the mountains scatter blue light. The farther away the mountains are, the more blue light is scattered into our eyes, and, in a sense, this dilutes the light coming to us from the mountains themselves.

But there is a second effect that is related to the structure of the eye. The task of the lens is to focus the rays of light in such a way that a sharp image appears on the retina. Just as blue light is more intensely scattered across the sky, its refraction by the lens is more intense. For this reason the eye cannot focus sharply on both red and blue at the same time. That is why it is so unpleasant to read red writing on a blue background.

In order to focus sharply on a blue object, the eye has to relax the little ring-shaped muscle around the lens so it becomes flatter. It is the same movement that is needed to focus on a faraway object. Our brain does this automatically. However, it may have the subconscious effect of making us associate the color blue with distance. It's also possible that artists such as Kandinsky and Goethe, who spent decades training their eye, were more conscious in their appreciation of this effect than most of us.

WHEN BLIND PEOPLE SEE BLUE

In 1927, the scientist Clyde Keeler, who was just twenty-seven at the time, published an astonishing work. A few years earlier, his girlfriend had given him a pair of white mice, and since then he had kept them in his room at Harvard, where he was studying zoology. When Keeler's professor asked him to dissect the eyes of a few tropical birds, the young scientist decided to practice on the eyes of one of his mice first. To his surprise, he established that the animals were blind. Their retinas had neither cones nor rods. Keeler discovered the genetic defect that was the cause. But in his 1927 paper "Iris Movements in Blind Mice," he described another discovery: Even though the mice were completely blind, their pupils narrowed when he shone a light on them. Were there other cells in the eyes, apart from cones and rods, that could perceive light?

Most scientists scoffed at Keeler's hunch. The retina and its cones and rods had been intensely studied for decades, and it seemed inconceivable that scientists would have missed the presence of other cells in the eye that reacted to light. In subsequent years there were occasional indications that Keeler may have been on the right track after all. But it was not until 2002, seventy-five years after Keeler's publication, that scientists finally published confirmation of this in the journal *Science*: A few nerve cells in the outer layer of the retina, called ganglion cells, possess a light sensor, the molecule melanopsin. It reacts to blue light.

These cells do not contribute to vision, but they do help to coordinate countless other processes in the body. One of these is the reflex that causes the pupil to narrow when too much light shines into the eye. Another is our inner clock. Many processes in the human body are tied to the twenty-four-hour cycle of the day: our sleeping/waking rhythm, for example, but also the

release of various hormones, and even our mood. This inner clock has to be synchronized with the world outside again and again; and one of the indicators of time is light. The melanopsin in the ganglion cells seems to play a decisive role in this process.

In a study that was published in 2007, researchers examined two blind people: a fifty-six-year-old man and an eighty-seven-year-old woman. As with Keeler's mice, both lacked all cones and rods. Despite that, scientists could move their inner clocks backward and forward with the help of light—blue light.

But not only that. The authors established additional facts in their research: The brain waves of the blind man changed when he was exposed to blue light. At such times he showed more alpha waves, a sign of alertness. And the woman could tell when a light was switched on, though only light with a wavelength of 480 nanometers—the wavelength of the blue light absorbed by melanopsin. And although neither of these people could see, blue light did have an effect on them. What other effects could blue light have on us without our being aware of it? Scientists are just now starting to investigate this. What they find could have far-reaching consequences, because we are all surrounded by more and more blue light.

BLUE LIGHT

The twentieth century was illuminated by the incandescent lightbulb. After Thomas Alva Edison patented his invention in 1880, it began to be used by people all around the world. (It is worth pointing out, however, that even today, one in ten people do not have access to electricity.) In the bulb, an electric current heats a thin wire, which then starts to shine. The radiation it emits is not evenly distributed. The wire gives off only a

small amount of blue light, but as you travel along the spectrum to longer wavelengths, the intensity of the light increases as it moves from green and yellow toward red. Most of the energy isn't transformed into light at all: It is given off as invisible infrared radiation—as warmth. This inefficiency is why countries around the world, including the United States, have been phasing out these bulbs.

In contrast to bulbs, light-emitting diodes, known as LEDs, produce monochromatic light. They do not emit any warmth, and they use much less energy. Red and green LEDs were developed as early as the 1960s. But despite years of research at the end of the '80s, a blue LED-emitting light was not developed—which was necessary in order to produce white light.

Most researchers tried their luck with zinc selenide. The Japanese inventor Shuji Nakamura, who was working for a small firm called Nichia, decided to investigate a material that wasn't used as frequently: gallium nitride. In 1991, Nakamura cultivated the purest gallium nitride crystals that had ever existed. In 1993 came the breakthrough: the first commercial blue LED light. Along with two colleagues, Nakamura was awarded the 2014 Nobel Prize for Physics for "the invention of efficient blue light-emitting diodes, making bright and energy-saving sources of light possible."

Today, these sources of light are universal. They glow from the screens of cell phones, TVs, laptops, and tablets. They light up our homes and illuminate our places of work.

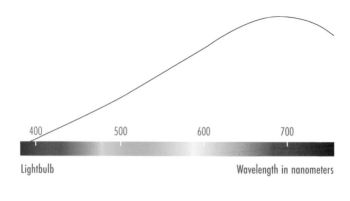

Lightbulb

Wavelength in nanometers

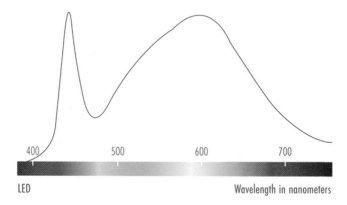

LED

Wavelength in nanometers

Most white LEDs are actually blue LEDs that are combined with the substance phosphorus. The blue light stimulates the phosphorus, which then gives off a yellow glow. We perceive the blue and yellow light as white. One consequence is that LED light contains far more blue light than the light emitted by electric bulbs.

What does constantly bathing our bodies in this blue light mean? It is widely accepted that blue light is capable of causing particularly significant changes in our sleep-wake cycle. As a result, many cell phones now have a night mode, which emits

less blue light. But many scientists suspect that there are additional effects that are less evident so far. Could blue light even be healthy? It has long been known that lack of daylight during the winter months can lead to a minor form of depression, and at times this is treated with light therapy. Blue light seems to be especially effective for that. Is melanopsin also responsible for this effect? For the moment that is speculation. But ninety years after Keeler discovered that his blind white mice could react to light, scientists have started to investigate what else blue light might be doing to us, apart from letting us see the beauty of the world.

IMPOSSIBLE BLUE

Even though we humans have only three types of cone cells, we still perceive four primary colors: In addition to red, green, and blue, we also perceive yellow as a color that is not composed of other colors. These four colors can be arranged in two pairs of complementary colors: red and green, blue and yellow. We can perceive a transition from blue to red (violet) or a transition from blue to green, but no transition from blue to yellow. There is no yellowish blue.

The reason for this lies in the way the eye's sensory cells are wired together. Even before any signal is transmitted to the brain, the first step in processing color takes place. In specialized nerve cells, the signals from the red and green cones are set off from each other. So it is not just the signals from the red and green cones that are transmitted, but the difference between the two signals. For blue, the calculation is more complicated, since the signal of the blue cone is compared to the sum of the signals from the green and red cones. That essentially creates a

blue-yellow channel: Blue is always the absence of yellow, and vice versa.

This color calculation in the retina is also responsible for the afterimages we see when we close our eyes after staring at one color for some time. If, for example, you look at a blue area for thirty seconds without moving your eyes, then the retinal in the blue receptors is used up. If you then look at a white surface, you will see a yellow afterimage, because the exhausted blue cones are not producing a signal anymore, and your brain interprets that as a yellow signal.

Some scientists maintain that these mechanisms allow us to see colors that are physically impossible—for example, a blue that is as dark as black. The philosopher Paul Churchland published the instructions for that in a 2005 article.

First of all, look at the yellow circle for twenty seconds, fixing your gaze on the cross in the middle. Afterward look at the cross in the middle of the black square. You should see a blue circle standing out against the black background. No object that exists in the world outside can have this color: It is at the same time blue and as dark as black. It is a color that can only exist inside your head because of the way your retina and brain interpret the signals from the outside world. And this is not the only case in which our brain is deceiving us.

THE BLUE DRESS

People who are getting married don't have to agree on everything, but what happened in February 2015 on the Scottish island of Colonsay was unusual. Shortly before the wedding of Grace MacPhee and Keir Johnston, Grace's mother sent the couple a snapshot of the dress she had just tried on in a shop and was going to wear at the wedding. The astonishing thing was that the bride and groom couldn't agree on what color the dress was: Was it blue with black decoration, or white with gold decoration? Grace uploaded the photo to Facebook, and her friends couldn't agree either. Soon the whole island was arguing about the colors. An acquaintance posted the photo on Tumblr, and the internet exploded.

Within a few hours, the photo of the dress had been seen by millions of people. BuzzFeed announced that at one moment 670,000 people were viewing an article on the dress at the same time. A piece by the science journalist Adam Rogers was viewed more than thirty million times. On Twitter people were arguing about the colors of the dress in multiple languages. All sorts of celebrities joined in: Kim Kardashian announced that she could see gold and white. Kanye West, on the other hand, saw blue and black. Singapore's prime minister was in the white camp, Justin Bieber and Taylor Swift in the blue camp. "From this day on the world will be divided into two groups of people. Blue and black or white and gold," wrote Ellen DeGeneres on Twitter.

What had happened? The key is a phenomenon that scientists call color constancy. This is our brain's attempt to keep the perceived color of objects consistent, even though the light they reflect is always changing. One example: If you put this book down under the lamp in your office, it will reflect a completely different light than when you put it in the sun on your balcony, simply because the light from your desk lamp and the light of

the sun are made up of different wavelengths. Despite that, the peacock always looks blue and green to us. To pull off this trick, our brain has to do quite a bit of work. It essentially analyzes what the illumination is like and then subtracts it out.

Color constancy can be used to create all kinds of optical illusions. For example, it underlies the strange effect in the illustration below. The two eyes are exactly the same gray color. But the eye on the left appears yellowish because the brain interprets the blue tone that is superimposed on it as a filter and subtracts it.

As a rule, we don't notice this effect, because our brains all do the same thing. But there was something different about the dress. Obviously the photo wasn't unambiguous, and the brain could interpret it in various ways: Some people saw a white-and-gold dress in a bluish light, others a blue-and-black dress in a yellow light. Why? A few months after all the stir about the dress, a few scientists ventured an explanation in the journal *Current Biology*. Perhaps people who get up later and tend to work at night see a blue dress in a yellowish light because their brains are accustomed to artificial light. People who work during the day are more accustomed to the bluish daylight, and so their brains subtract a greater amount of blue from the picture, causing them to see a white dress. In fact, the results of an online survey published by neuroscientist Pascal Wallisch in 2017 seemed to confirm that. People who described themselves as night owls were much more likely to see the dress as blue.

In reality, the dress was blue and black. But what does that even mean? Of course, beauty is in the eye of the beholder. But are colors, too? Then what is actually out there?

The phenomenon of color constancy shows us that many of our assumptions about color are wrong. Once you accept this uncertainty and follow it deeper and deeper, you end up going from physics and physiology to philosophy. And to the core of what it means to be human—to be experiencing this moment here and now.

THE COLOR OF CONSCIOUSNESS

The color blue reminds Thomas Metzinger of a problem. In the mid-1990s, the philosopher was working on a collection of essays about research into consciousness. The dust jacket of the

book was to be blue, Metzinger had decided. And not just any old blue, but the blue the French painter Yves Klein had made famous. "I was going through my Yves Klein phase back then," Metzinger says today. But the artist's special ultramarine blue was patented and prohibitively expensive. In the end, Metzinger was forced to switch to another blue, the shade Pantone Blue 072.

The color blue also reminds Metzinger of a much greater problem, one that has occupied him for decades and to which there is so far no solution. Metzinger is interested in the puzzle of human consciousness. At its core, this is about "what it is like" to experience something consciously, and why it is like anything at all. And it is about whether "what it is like" can be explained by the natural sciences. Philosophers also call "what it is like"—this subjective experiencing of a mental state—"qualia," and they call the questions it raises "the qualia problem." Metzinger's intention was to express this problem in the color of the dust jacket: "I was thinking, *What would be the number one example for the reader?* And for me that was the color blue."

What makes blue so puzzling is that it seems so clearly to be "out there," even though it only exists inside our heads. "Out there all that exists is an ocean of electromagnetic vibrations," Metzinger says. And none of those vibrations is blue in itself. Newton had already realized that. "For the Rays to speak properly are not coloured. In them there is nothing else than a certain power and disposition to stir up a Sensation of this or that Colour," he wrote in his 1704 book *Opticks*.

So blue light is not actually blue. Light of the wavelength 430 nanometers merely creates the sensation of "blue" in our brain. And that blue can't be found inside our brain either. The nerve cells, the electrical impulses they send along the optic nerve, the patterns of excited neurons in our brain—none of that is in any sense blue.

But what does it mean, then, that a cornflower is blue? Philosophers have attempted to explain this in a variety of ways. For some of them, blue is like pain. We say a tooth hurts, but that is a projection. The pain is inside our brain, and we localize it in our tooth. Do we project the property of "blue" onto a cornflower in the same way? Others compare the property "blue" with the property "poisonous." A substance is not simply poisonous or nonpoisonous. It can, for example, be poisonous for humans without being poisonous for dogs, ducks, or dolphins. Similarly, an object might be blue for humans even if it is not for other animals.

But these comparisons don't bring us any closer to the crucial question. Can the natural sciences fully explain the experience of blue, that feeling I had on the ferry in Greece? That is the nub of the question philosophers have been circling around for more than a century.

What the prism was for Newton, the thought experiment is for philosophers. One of the most famous thought experiments concerns a brilliant woman named Mary. Mary knows everything there is to know about the world. She knows the laws of nature, from the smallest elementary particles to the infinite reaches of the universe. But Mary has spent her whole life in a black-and-white room; everything she's learned, she has learned from a black-and-white monitor in her room. In brief: Mary knows everything about color, but she has never seen a color, never experienced blueness. So what will happen when she is let out of her room for the first time and sees the blue sky? Will she learn something new at that moment? The philosopher Frank Jackson, who came up with this thought experiment in the 1970s, claimed that Mary does learn something new. It was obvious, he argued, that she would learn something new about the world and visual perception. But that would mean that she didn't actually know everything to begin with. Clearly there was

knowledge that could not be reduced to physics, Jackson argued. So does Mary's story prove that science is not enough to explain consciousness?

The thought experiment provoked countless responses and modifications. Is it even possible that Mary has no experience of color? Can she not dream of color? Is that important? What if she is physically incapable of seeing color and is given that ability through an operation? What does Mary learn then? And what do we learn from Mary?

I don't believe that these questions are decisive. There is another reason I'm not convinced by the thought experiment. What does it mean to say Mary knows "everything"? That is simply beyond my imagination. And since that is the case, I can't rely on my intuition for the answer. Ultimately it throws me back on the assumptions I already had. If I believe "everything" is explicable through science, then Mary isn't learning anything new anyway. If I believe there are some things that cannot be reduced to physics, then I do believe that Mary learns something new upon seeing the sky. After the thought experiment, I'm no wiser than I was before.

And yet there is something to it. What fascinates me about Mary is the moment when she leaves her black-and-white prison—that experience of seeing the blue sky for the first time. The feeling must be overwhelming, indescribable.

And we have the possibility of marveling at this blue every day. All the effort our brain expends to create that sensation of "blue"—and we take it for granted.

Perhaps we ought to imagine ourselves in Mary's place more often. That might not help us to solve the problem of consciousness, but it might at least help us to enjoy it.

Which is something I resolved to do while writing this book: to look out into the world more often, as if I were seeing all its colors for the first time, and to say to myself, "Whoa! A blue sky."

PLANTS

Oh, these eternally green trees, why can't they be blue once in a while . . . ?

—GOTTHOLD EPHRAIM LESSING

The cornflower comes from the
Mediterranean region. Mixed with grain,
its seeds spread all over Europe.

One of the first things that catches my eye as I walk through the streets in Japan is a big blue vending machine that sells drinks. In the following days I stumble across these metal boxes again and again. You can buy coffee and a variety of soft drinks from them. But what draws my attention is the huge logo on the side: SUNTORY.

I first came across that name in the film *Lost in Translation*. In it, Scarlett Johansson drifts around Tokyo, while Bill Murray plays an aging Hollywood star shooting a commercial for Suntory whisky. Again and again he has to turn to the camera and say, "For relaxing times, make it Suntory times." The advertising campaign in *Lost in Translation* is based on a true story: Suntory has shot commercials for its whisky with stars like Sean Connery.

I, too, have come to Japan because of Suntory. Not because of its whisky or the multitude of other drinks the company produces, but because of its flowers.

In the 1980s several tax hikes drove up the price of alcoholic drinks in Japan, and Suntory started to invest in other areas. One of these was cut flowers. The company decided to aim for an unusual goal: creating a blue rose.

In many myths and stories, whoever finds a blue rose reaps fortune and fame. Or love. Rudyard Kipling, author of *The Jungle*

Book, devoted a whole poem to the blue rose. In it, a suitor goes in search of the coveted flower at the request of his beloved: "Half the world I wandered through, / Seeking where such flowers grew." He searches and searches but cannot find them. When he finally returns home empty-handed, his love has died.

At Suntory, myths have also grown up around the company's quest to make a blue rose. It is said, for instance, that the owners of the company were trying to color the English rose a Scottish blue in gratitude for the invention of whisky.

A more likely explanation is that the project simply seemed like a good business bet. Cut flowers are worth more than thirty billion dollars a year. And blue is a scarce commodity. Tulips, chrysanthemums, carnations: None of these bloom blue. Blue orchids are usually white flowers that have been artificially colored. And then there's the blue rose, symbol of the unattainable, the impossible.

THE BLUE FLOWER

Rudyard Kipling was not the only one: Artists realized early on that there is something special about blue flowers. At the very beginning of his novel *Heinrich von Ofterdingen*, the author, Novalis, has young Heinrich muse over the stories of a stranger: "It's not the treasures that have aroused such an ineffable desire within me, he said to himself; all avarice is far from me, but I long to see the blue flower."

Innumerable theories speculate as to which flower Novalis could have had in mind. One candidate is the cornflower. It was a sad symbol for the author. In 1794 he had just gotten to know twelve-year-old Sophie von Kühn and had fallen in love with her. They got engaged, but Sophie died from tuberculosis at

the age of fifteen. Novalis was devastated. A friend, the painter Friedrich Schwedenstein, is said to have given him a painting depicting dried cornflowers in consolation. A few years later, Novalis also died of tuberculosis; his novel about the young Heinrich remained a fragment. But our fascination with the blue flower continues.

In German Romanticism, it became a symbol of longing. "I seek the flower of blue / Seek yet never can find. / I dream that in its hue / My happiness is enshrined," wrote the poet Joseph von Eichendorff. The blue flower is "that which everyone longs for, without being aware of it, call it God, eternity, love, I or you," wrote the poet and historian Ricarda Huch.

In Hollywood, too, the blue flower still blooms. In *Batman Begins*, the first part of Christopher Nolan's brilliant Batman trilogy, Bruce Wayne searches in the mountains of Bhutan for a rare blue flower. His adversary, the crazy psychiatrist Jonathan Crane, later uses a chemical contained in the flower to create a dangerous nerve gas. In the film *A Scanner Darkly*, based on the novel by Philip K. Dick, the powerful drug called Substance D is made from a blue flower. And in the animated film *Zootopia*, a blue flower produces a substance that turns peaceful mammals into dangerous beasts. The motif keeps cropping up. Very few Hollywood directors probably know how right they are when they portray the blue flower as a kind of natural factory for rare chemical substances.

Walk through the fruit and vegetable aisles of a supermarket and try to put a nice blue meal together. It's enough to drive you to despair. The lettuce and the cucumbers are waiting there, green and healthy. Tomatoes and strawberries are competing for your attention in bright red, lemons and summer squash are emanating yellow, and oranges are living up to their name. Bell peppers are available in all four of those colors. Raspberries and currants

are there in black and red, apples in red and green, olives in green and black, grapes, too. But you will search for blue in vain. You may end up with a few blueberries—healthy, but not exactly a full meal. And more deep purple to black than true blue.

In the rest of the plant kingdom, blue doesn't fare much better. Nature is teeming with green and red, and yellow blossoms are all over the place. But blue is clearly special—especially rare. Of course, there are violets and forget-me-nots, but very few flowers bloom as blue as gentian. "Flowers are doing crazy chemistry to generate that blue," says the botanist Beverley Glover.

No wonder, then, that not only artists but scientists, too, have succumbed to the longing for the blue flower. Some try to understand what is special about plants that have mastered blue. Others want to use the pigments of those plants to color fabrics or food. And some, like the researchers at Suntory in Japan, want to extend the spectrum of nature and get blue blossoms to bloom where so far there are only red, yellow, or white ones.

I have come to Japan to meet Yoshikazu Tanaka, the scientist who has been working on the blue rose at Suntory for thirty years. I hope to understand what is so special about the color blue in plants. And I hope to see the rose he has cultivated in the lab.

I, too, am searching for the blue flower.

GREEN GAP

To understand what is so difficult about Tanaka's task, it helps to take a quick look at the palette of plant pigments, starting with the most common color in the world: the green of a leaf.

If you go out for a walk in nature anywhere in the world, chances are you will be surrounded by green. That is not surprising; the mass of all terrestrial plants is estimated to be roughly one thousand times greater than the mass of all animals. And most terrestrial plants are green. The color comes from chlorophyll. It is probably the most common pigment on our planet—and one of the most important inventions in the history of life.

If you paid attention in school, you will know that chlorophyll plays a decisive role in photosynthesis. In this process, plants use the energy of sunlight to convert water and carbon dioxide into sugar and oxygen. This chemical reaction is the basis of almost all life on Earth. It allows plants to grow and flourish using only solar energy, and ultimately supporting animal life, including us.

Chlorophyll is what allows plants to capture the sunlight. The molecule looks a little like a miniature version of a rattle: a long shaft of carbon atoms topped by a ring with a magnesium atom at its center.

If that magnesium atom is lost, which can happen during cooking, for example, the color of the molecule changes, which is why cooked peas or broccoli look paler than the raw vegetables. Chlorophyll does not contain chlorine, by the way; the word comes from the Greek *chloros*, which means "green." But why is chlorophyll green?

Chlorophyll absorbs light that is mainly in the red and blue range of the spectrum. The rich green of the leaves is what is left after the plant has absorbed the light it needs to live. Scientists call that the "green gap."

Does that mean that plants do not use the green range of sunlight for photosynthesis? More than a hundred years ago, the biologist Theodor Wilhelm Engelmann examined that question in an elegant experiment. Engelmann directed sunlight through a prism, separating it into stripes of various colors. He then let that rainbow fall on a bowl of water in which a strand of alga and countless oxygen-loving bacteria were floating.

Chlorophyll

- Carbon
- Oxygen
- Nitrogen
- Magnesium

As soon as the light struck the alga and it started to produce oxygen, the bacteria gathered around the alga. The bacteria flourished in places where red or blue light hit the alga. Clearly, oxygen was being made in those spots. But the part of the alga on which green and yellow light fell did not seem to attract the bacteria. No photosynthesis took place there.

Plants really do not use green light. And yet more of the Sun's energy arrives on the surface of Earth in the green range than in any other part of the spectrum. Wouldn't it be more efficient for plants to use that light? Or to simply absorb all light, which would make them black?

Astonishingly, that is a question scientists have not found the answer to yet. To be more precise: They have plenty of answers, but it is not clear which one of them, if any, is the right one.

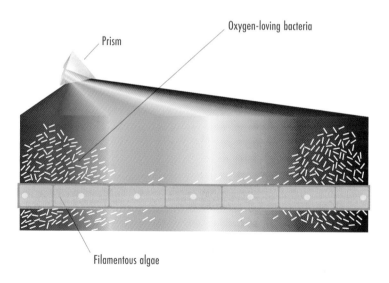

Oxygen-loving bacteria

Prism

Filamentous algae

One theory is known by the name "Purple Earth." It is based on the idea that the earliest microbes used a different molecule, called bacteriorhodopsin, for photosynthesis. Today, that molecule is still used by some microorganisms that live in water with a very high salt content. Bacteriorhodopsin absorbs green light, and that is why it appears purple. The hypothesis: The microbes that emerged later and used chlorophyll were stragglers and had to work with the light that their competitors had left them—and so they learned to live off of red and blue light. Since chlorophyll was more efficient overall, these microbes ended up winning in the Darwinian struggle for existence and became the ancestors of land plants.

COLORFUL LEAVES

Besides green chlorophyll, a number of other classes of pigments are found in plants. The betalains, for example, color beets, the fly agaric, and bougainvillea red.

A much larger class is the carotenoids. They give the carrot its color and make tomatoes and bell peppers appear red. Carotenoids are the source of the yellow in corn, bananas, and buttercups. They are also present in tree leaves. For most of the year, the green of the many chlorophyll molecules outshines the carotenoids. Only when the chlorophyll is broken down in autumn do the yellow molecules become visible.

Carotenoids have two very important tasks in the leaves. On the one hand, they help to reduce the green gap a little. Carotenoids can absorb green and blue light and pass on the energy to a neighboring chlorophyll molecule. That is why they are called antenna pigments. But the carotenoids can do even more:

If very strong sunlight is falling on a leaf and the photosynthesis apparatus cannot cope with it, carotenoids can transform the excess energy into warmth and release it. This protects the leaf from damage.

Some animals also use carotenoids for color. Flamingos and scarlet ibis color themselves red by ingesting the molecule carotene in their food and then storing the pigment in their plumage. The red of the ladybug comes from another carotenoid: lycopene. The same molecule gives tomatoes their color and also part of their taste.

And then there are the anthocyanins, perhaps the most splendid of plant pigments. They color cherries and corn poppies, but also raspberries, strawberries, and cranberries. And they are the reason for the red fall foliage. In autumn the trees reduce the amount of chlorophyll in their leaves and at the same time start to produce anthocyanins. This may protect the leaves from damage caused by strong sunlight. The leaves will soon fall off anyway, but before that happens the tree tries to extract as many resources as it can from them to store over the winter. The anthocyanins help protect the leaves during this phase, in much the same way that soldiers in a retreating army protect their comrades while they pack up camp.

All these colors in the plant kingdom are a kind of by-product. Plants need the energy of light to live, and when they absorb certain wavelengths, the remainder, which they reflect, appears colored. But why is this remainder so rarely blue?

One explanation comes from the chemistry of plant pigments. It appears to be extremely difficult for nature to produce a molecule that absorbs red light, which is what would be needed to appear blue. Neither chlorophylls nor betalains nor carotenoids occur in blue flowers. In fact, among all the pigments in the plant kingdom, there is only one group that is capable of coloring a blossom blue: the anthocyanins. Indeed, that is why

these molecules bear that name. In his 1835 book *Die Farben der Blüthen* ("The colors of blossoms"), the pharmacist Ludwig Clamor Marquart coined the name *anthocyan* for the blue pigment. It simply means "blossom blue."

THE SECRET OF THE CORNFLOWER

During the nineteenth century, countless scientists attempted to isolate this "blossom blue" and determine its composition. But again and again they failed, in part because the pigment broke down so quickly. "Sixty years have passed during which the chemical investigation of the pigment of blue flowers has made no progress," the German chemist Richard Willstätter wrote in 1913.

Willstätter was one of the most important scientists of his age. He had deciphered the structure of cocaine and shown that chlorophyll appears in two different forms in plants, chlorophyll A and B. After his work on leaf green, Willstätter had turned to the blossom blue of the cornflower "because of its beautiful, fairly pure blue color." Willstätter succeeded where others had failed: He isolated the blue of the cornflower, identifying a molecule he called cyanidin.

Two years later, Willstätter succeeded in doing the same with the red rose. He found something astonishing: The pigment he isolated was the same one he had found in the cornflower. But how could the blue of the cornflower and the red of the rose come from the same pigment?

Cyanidin
- Carbon
- Oxygen

Scientists already knew that anthocyanins such as cyanidin change color according to the pH value—that is, according to the acidity of the liquid they're floating in. You can easily observe this: Cut up a red cabbage into small pieces, cook them in water, then drain off the water through a sieve and let the liquid cool. If you add soap to the juice, it will turn blue. If you add enough lemon juice, it will turn a vibrant red. (I was the kind of kid who actually did stuff like this. At least until I was given the Kosmos Chemistry 3000 Experiment Kit and my experiments were moved from the kitchen to the basement.)

The pigments that color a petal are located in the outermost layer of cells, and in a special place within these cells: the vacuole. This is a kind of gigantic balloon of water in the middle of the cell, which, among other things, gives the cell its stability. Willstätter suspected the cell sap in the vacuole of the rose was more acidic than the cornflower's, and that that difference in pH value was the source of the different colors: "Therefore this example confirms that some variations in the color of flowers are determined solely by the acidic, neutral or alkaline reaction of the cell sap," he wrote. It was the first scientific theory about the blue color of flowers. But was it right?

Two Japanese brothers, Keita and Yuji Shibata, one a plant scientist, the other a chemist, soon expressed doubts about Willstätter's theory. The cell sap in petals is usually slightly acidic, and it seemed to them unlikely that a flower could change that. The two proposed a different explanation: They had found that anthocyanins retain their blue coloration in an acidic liquid if metals such as magnesium or calcium are present. The atoms of those metals are present in water as positively charged particles, and these ions appear to stabilize the pigment molecules with their positive charge. The brothers' hypothesis: The cornflower uses such metallic ions to achieve its radiant blue.

There was another flower the brothers could point to: the hydrangea. Gardeners had long known that the pink blossoms of hydrangeas can be turned blue by adding alum to the water—a substance that releases aluminum ions.

Over the following decades scientists used ever more elaborate methods to unlock the secret of cornflower blue. It soon became clear that cyanidin and metal ions alone could not be the answer. When scientists carefully removed the pigment from the flower, it seemed to be much heavier than cyanidin alone. Was the pigment actually a collection of different molecules?

As early as the 1930s, scientists had devised a third theory to explain blue flowers: Maybe the anthocyanins in these plants are being supported by other molecules. They called these substances copigments. Copigments were themselves colorless, but could stabilize pigments like the blue of the cornflower. Over time, this theory came to seem more and more likely.

In 2006, scientists finally made a breakthrough. They produced an X-ray crystallographic structure of the cornflower's pigment. The idea behind the method is simple: X-rays are sent through a sample of pigment and then collected on the other side. Because electrons slightly divert the path of the rays, the

resulting pattern makes it possible to calculate the precise position of atoms in the structure.

In practice, however, this is incredibly difficult, and while science journalists do not report on such structures very often, they are of immense importance for science. The images Rosalind Franklin (working with PhD student Raymond Gosling) made of DNA molecules using X-ray crystallography were a crucial part of convincing Watson and Crick that our DNA must be in the form of a double helix.

The puzzle of cornflower blue, too, was eventually solved using X-rays. The scientists found an elaborate molecular complex: six molecules of cyanidin and six copigment molecules arranged around one atom of iron and one of magnesium, like the spokes of a wheel. This was the secret of the flower's blue color.

Many other plants create their blue blooms using the same recipe: six molecules of anthocyanin, six molecules of a copigment, and two ions of a metal. That is how the deep blue of Mexican sage and baby blue eyes comes about—as well as the coveted blue of the common dayflower, which is anything but common. The dayflower blossoms for just one day, but it is all the more beautiful for that. In the flower's home, in Asia, its pigment has long been used by artists.

Above: The blue of the dayflower (left) and of sage (right) comes about through the same complex chemistry as the blue of the cornflower.

Below left: Gardeners have long known that they can turn hydrangea blossoms blue by adding alum to the water.

Below right: A few species of morning glory can change the pH value in the cells of their blossoms to make them appear blue for a short time.

WILLSTÄTTTER'S FLOWERS

Richard Willstätter was not granted a happy ending. He did receive the 1915 Nobel Prize "for his researches on plant pigments." But in that same year, his only son died and Willstätter's work was interrupted by the First World War. Instead of studying beautiful flowers, he was now working on a new filter for gas masks. "The pigment solutions from stemless gentian of Lugano, from Dutch tulips, from raspberries and strawberries spoiled, the cultures of colorful blossoms went unharvested at first, then we carried the beautiful flowers in baskets to the military hospitals," he wrote in his memoirs.

After the war, Willstätter was free to pursue his research again, but he did not want to return to his previous work. "The study seemed to me like an unfinished torso, for years I couldn't think of it without pain." Instead, he decided to devote himself to teaching at the University of Munich, which he had transferred to: "After the war it was more important to produce lecturers than to do research and write treatises." But Willstätter was Jewish, and the ever more aggressive anti-Semites did not spare him. Even as Willstätter was being appointed full professor, the king of Bavaria, Ludwig III, cautioned his Minister of Education, "This is the last time I give you my signature for a Jew." The situation at the university became worse and worse, and in 1924 Willstätter resigned his post in protest. In 1939 he finally had to flee Germany, losing almost everything in the process. He died in Switzerland in 1942.

Willstätter's theory about the blue of the cornflower was wrong. But that might not have bothered him much. Not possessing the truth, but struggling for it, was what made a scientist happy, he had said in his speech upon accepting a prestigious prize in Chicago in 1933. "Much which we sow will be reaped by others."

And Willstätter's seed would germinate. His work inspired future research into plant pigments. As the chemist Emil Fischer is said to have told him, "You taught us to bring the plants themselves into the laboratory."

In the decades after Willstätter's death, it turned out he had not been entirely mistaken: Some plants do indeed change their pH value in order to appear blue.

The morning glory (*Ipomoea tricolor*) is a sky-blue climbing plant native to Mexico. It owes its name to the fact that it opens its blossoms only briefly in the morning. But while it does, its blossoms change their color, from red to blue. Scientists have been able to show that in order to do this, the plant shifts the pH value in the cells housing the pigment from 6.6 to 7.7.

Japanese researchers have posted a beautiful time-lapse video on the internet that shows a morning glory as it grows, forming a rose-colored bud that opens for an instant, shining a beautiful blue before crumpling. It is difficult for me to watch that video and not see a metaphor for Willstätter's life.

AN APPETITE FOR ANTHOCYANINS

Cathie Martin is fascinated by a blue flower as well. The British scientist giggles when she says the name: *Clitoria ternatea*, the butterfly pea. Of course it was men who gave the plant its suggestive Latin name. The blossom of the plant does indeed resemble a clitoris, and in some cultures it is used as an aphrodisiac or to treat gonorrhea. That practice presumably follows the "doctrine of signatures," an ancient idea that posits that the Creator wants to show us what plants should be used for by their resemblance to different body parts (by the same logic—and likely, with a similar level of success—one could

prescribe walnuts for brain diseases and carrots for erectile dysfunction).

Where this evergreen plant originated is unclear, but today it is widespread across the globe. In Malaysia the flowers are added to rice as it cooks in order to turn it blue. In parts of Southeast Asia, a blue tea is made from the flowers.

And in Norwich, in the east of England, the butterfly pea is growing in a greenhouse at the John Innes Centre. It is there that Cathie Martin has been researching anthocyanins for many years and has come across an interesting problem: There is a lack of good pigments for coloring food blue.

That might not sound like a big deal—after all, most of the foods that humans eat aren't blue. But for sweets, drinks, chewing gums or cake frosting, yogurts and some cereals, blue is required. And there is another reason why the food industry longs for blue. "We must have blue to make all the colors of the spectrum," says the chemist Richard van Breemen of Oregon

Some cultures use the petals of the *Clitoria ternatea* to color foodstuffs blue.

State University in Corvallis. "It is possible to get away with using some green mixed with yellow or red, but using blue gives a much more vibrant, wider color range."

Blue could be combined with a shade of yellow, for instance, to produce a rich green. For green is also scarce. True, chlorophyll is licensed as pigment E140, but, as noted earlier, the molecule can easily lose its atom of magnesium and with that its strong color. One possible fix is to replace the magnesium atom with an atom of copper. That results in a more stable green color, which is licensed as pigment E141; whether it can still be declared a "natural" pigment, though, is a matter of debate.

With the blues, there are basically three possibilities: The most commonly used blue pigment is brilliant blue, or E133 in the language of licensing authorities and ingredient lists. That pigment is used to color blue M&M's, as well as the potency pill Viagra. The second pigment is E132 or indigotine, related to the denim pigment indigo. And then there is Patent Blue V, E131. This substance's fate reveals some of the problems of the food industry, for Patent Blue V is not approved in the United States. Scientists suspect it may cause allergies. In Europe, on the other hand, the molecule is used to color countless foodstuffs, including Blue Curaçao liqueur.

All three pigments are artificial. But customers are increasingly demanding natural ingredients. At the moment there is only one source of natural blue: spirulina, an extract from the blue alga *Arthrospira platensis*. The bacterium is mostly cultivated in open tropical waters, then harvested, after which the pigment is extracted from it. The main problem is that the algal protein that carries the color changes and grows pale under UV light. "And it's a terrible blue," Martin says. "It's actually more of a green."

That's why many scientists are scouting the natural world for a new blue pigment, be it from algae, fungi, or plants. Van

Breemen has searched for blue pigments in microorganisms that live under extreme conditions, such as the hot springs of Yellowstone National Park.

The reason the search has proven difficult lies in the form of the molecule, Van Breemen says. Basically, organic molecules consist of atoms of carbon and hydrogen. They generally absorb light by using the energy of a light particle to raise an electron from one energy level to the next. But for that to occur, the light has to have exactly the right amount of energy. Red light has the lowest amount of energy of any light in the visible spectrum, and therefore a molecule can absorb red light only if the energy levels of its electrons are very close to each other. That is more likely to be the case the larger and more intricate a molecule is. "To put it in simple terms: The more complex the structure of a molecule is, the more likely you are to get blue," Van Breemen says. But the more complicated a molecule, the more work it is for an organism to produce it, and the bigger the benefit must be to make that evolutionary effort worthwhile.

Van Breemen has found beautiful blue molecules in a few bacteria. But they were hardly suitable as food colorants. The bacteria weren't producing the molecules for their color, but as weapons in the fight against other microorganisms, making them more interesting as potential antibiotics than as pigments.

Martin hopes to be able to use the blue pigment of flowers such as the butterfly pea, a representative of probably the most important blue pigment from flowers. Some flowers have indeed learned to conjure up a stable blue from cyanidin by constructing gigantic complexes that stabilize the molecule or by making the liquid in their petals less acidic. But the blue of most blue flowers is not based on cyanidin, but on another anthocyanin: delphinidin.

Many flowers use molecules that are based on delphinidin in order to bloom in blue. The name derives from *Delphinium*, the

Latin name for the larkspur flower, which the molecule was first isolated from. Delphinidin is behind many of the best-known blues in the world, like that of the gentian. If there is a molecule for "blossom blue," delphinidin is it.

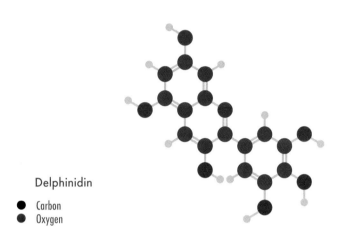

Delphinidin

● Carbon
● Oxygen

The delphinidin molecule differs from cyanidin in just one small detail: It carries an additional oxygen atom in one place. For the plant, this oxygen atom is like a little hook that additional atoms can be attached to. This way, the plant can embellish the molecule, building one that is bluer and more complicated.

In the butterfly pea, countless delphinidins develop that differ slightly in their ornamentation. In her lab, Martin has already colored ice cream and doughnuts blue. Now she is trying to find the most stable of the many delphinidins, explaining that most anthocyanins last for barely a single day. "And for foodstuffs we need something that lasts for at least three months."

Delphinidin is also the key to the secret of the blue rose.

A SHORT HISTORY OF THE ROSE

In 1904 the *Rosen-Zeitung* ("Rose gazette") carried a report on the red W. Francis Bennett rose, which had been sold a few years before for the immense price of twenty-two thousand marks. "Anyone who could make a cornflower-blue rose, even if it were only a simple one, even if it had just one purely blue petal, could expect just as much," the article said. "Whether it would be beautiful is another question; but it would be new, and novelty is what is most effective nowadays."

A blue rose may strike us as new and unnatural. But what exactly is the "nature" of a rose? Trying to answer this question, I ended up at one of the world's largest collections of roses, the Europa-Rosarium in Sangerhausen, in Germany's southern Harz mountains. In 1903, rose enthusiasts set up a garden for roses here in order to preserve rare forms of the flower. Thousands of kinds and species grow in this sanctuary: beach roses and burnet roses, cinnamon roses, cabbage roses, tea roses, moss and damask roses.

A huge wall chart in one corner of the Rosarium explains the relationship between all these roses. It is more confusing than the family tree of a European royal house. "And that is the very simplified version," says Thomas Hawel, the rosarium's director.

The ancestors of all roses are the wild roses. There are over a hundred types of these shrubs. They have been in existence for more than thirty-five million years, and they come almost exclusively from the northern hemisphere. As a rule, these flowers have simple blossoms of five petals, bloom in the summer, and then form rose hips in the autumn. In the rosarium there is, for example, the prickly rose, a shrub with beautiful pink petals and long, thin thorns that give it its name. These flowers remained largely unchanged for millions of years. Then humans appeared.

People probably began to cultivate roses in China a few thousand years ago. In any event, the flowers later reached Europe. In ancient Rome they were absolutely adored. A few historians even claim that some Roman emperors would let such huge quantities of rose petals rain down from the ceiling at parties that guests occasionally suffocated.

Until the late Middle Ages, however, there were only a few dozen species of roses in Europe. Their flowers were pink or white, and there was one respect in which humanity had already changed them: Some of the flowers were "double-filled," which means that instead of five petals, up to a hundred crowd together in the sumptuous bloom. This trait is caused by a mutation that occurs in the wild from time to time—it causes more petals to grow, instead of pollen-producing stamens. Such plants usually do not form any hips, so they can't propagate themselves naturally. In nature these plants would die out, but at the florist, they are now the norm.

Humans also weren't happy with the short time roses were in bloom. In the nineteenth century they succeeded in cultivating so-called remontant roses, which flowered a second time, in the autumn.

But something was still missing for roses to really break through. At the beginning of the nineteenth century, two rose species came to Europe from China—these were the first tea roses. And in 1867, Chinese tea roses and remontant roses began to be bred to create a new kind of rose, called the hybrid tea rose. These had splendid, long-lasting flowers, and with their development, a veritable boom in rose breeding began.

Now, new types of roses with novel characteristics were created almost daily. And, of course, humans set to work on devising new colors as well. The yellow rose had reached Europe from the Middle East in the sixteenth century, but only around 1900 did gardeners succeed in crossing it with a hybrid tea rose to

create a yellow garden rose. All modern yellow roses are derived from it. It transmitted not only its color to them, but also a susceptibility to the fungal disease known as black spot.

Today, all roses that followed the hybrid tea rose are considered modern roses. They are far and away the most widely sold flowers in the world. Why has the rose so fascinated humans? "There is simply no other ornamental flower that is as diverse as the genus *Rosa*," Hawel says. The shapes of the flowers, the colors, the fact that modern roses can be in bloom for months on end—these are the things that make them so popular.

A large part of this variety is due to human intervention, and it is perhaps the readiness of the rose to let itself be changed that explains its success. Estimates suggest that humans have cultivated more than a hundred thousand different roses. A modern rose from a florist is to a wild rose what a dachshund is to a wolf.

But in all the decades of cultivation and change, one thing has never been achieved: a truly blue rose. Yes, there are individual roses that are called "blue," but they tend to be purple at best. (One well-known "blue" rose is—of course—called Novalis.)

Given the wealth of colors already available, some people make fun of the desire for a blue rose. The writer Johannes Trojan even did it in verse:

Beautiful roses, wild and tame,
Set the garden and fields aflame.
Red, white, and yellow with heady scent —
But people, you know, are never content,
And ask, what's all this hullabaloo?
Why do you never see one that is blue?

That question at least can be answered today. The entire family of roses, which includes apples and pears, lacks the gene that would allow the flowers to produce delphinidin.

And so the rise of genetic engineering immediately brought back the desire for a blue rose. With this new technology, it suddenly seemed possible to produce such a flower. It would be a matter of inserting the appropriate gene from another plant into the rose, enabling it to make blue. The plant that suggested itself as the donor in this gene transplantation was the petunia, the favorite flower of budding plant biotechnology.

BLUE GENES

Early in its quest to create a blue rose, Suntory teamed up with the Australian biotech firm Calgene Pacific. Their first objective: to find the gene that allows petunias to produce delphinidin and patent it.

Delphinidin is a complex molecule, and plant cells form this and other pigments bit by bit, as on an assembly line. The workers on this assembly line are the proteins of the cell, each specialized to perform one tiny step. They take a particular molecule, change it in a specific way, and then release it again. The next protein takes the changed molecule, changes it a little more, and so on. Genes are the instructions for producing these proteins.

Delphinidin is produced in the petunia (and in other plants) from a precursor called dihydrokaempferol. Roses produce this molecule, too, but the protein they possess can only turn it into the cyanidin that Willstätter identified.

The genetic makeup of petunias has been investigated more thoroughly than that of most plants. In the first field trial with a genetically modified organism in Germany, scientists grew petunias that had a gene from corn inserted into them in order to change the color of the flower from white to orange. Now the scientists at Suntory and Calgene Pacific hoped they could transfer the petunia's blue color to the rose.

In 1991, Yoshikazu Tanaka and his colleagues succeeded in identifying the gene that allows the petunia to produce delphinidin. The first "blue gene" had been found—and was patented soon after. All the scientists had to do now was insert it into roses. Then the rose should produce delphinidin instead of cyanidin, and the blue rose would become a reality. "Back then we thought it wouldn't take much to do that," says Tanaka, who had been involved in the project from the very beginning. He's still working on it.

Tanaka was the scientist I had come to Kyoto to see. I met him in a brand-new research laboratory that Suntory had established on the outskirts of the city. In the brightly lit, sterile-white rooms were hundreds of little plastic tubes with miniature roses growing in them. They were genetically modified roses. One of them, Tanaka hopes, could one day grow true blue blossoms.

The path to such a rose begins with the leaf of a mature rose: The scientists cut the leaf into small pieces, put these in a petri dish, and add a mixture of plant hormones. This prompts the cells in the snippets of leaf to divide and grow into small lumps of cells called calluses. Scientists shuttle the foreign genes into calluses using a natural gene ferry: the bacterium *Agrobacterium tumefaciens*. Normally this pathogen infects plants, implanting its own DNA into them. But scientists have learned how to exploit this behavior for their own ends, loading the bacterium up with whatever gene they want to shuttle into the rose. Afterward, the callus gets a new hormone mix that stimulates it to grow, and out of the cluster of cells a tiny rose plant emerges.

After the Japanese scientists identified the gene for blue in 1991, they transferred it from petunias to white roses in this way. But when the plants finally blossomed, they weren't blue, and the scientists could find no delphinidin in them. Something had gone wrong.

The research team turned to carnations, and actually succeeded in creating a variety that produced delphinidin. The flowers went on sale in Japan in 1997. They were the first genetically modified flowers in the world to go on the market, but for Tanaka they were just a by-product. In roses, the gene from the petunias simply did not seem to take.

Tanaka and his colleagues then decided to use the gene from another flower, the pansy, and they finally managed to create roses that produced the blue pigment delphinidin. But it was still not enough to make the roses blue.

The research team tried their luck with dozens of different types of roses, finally creating one that produced delphinidin almost exclusively. In the summer of 2004, they announced their success to the world: They had cultivated a blue rose. In 2009, the flowers went on sale in Japan. Their name: Applause. But

The first "blue" roses Tanaka created aren't particularly blue.

when I finally see the flowers at Suntory in Kyoto, I don't feel like applauding. After my foray through the beautiful blues of the plant world, the Suntory roses seem, well, not very blue. I ask Tanaka what he thought when he saw the first of these blue roses in 2002. "Could be bluer," he replies.

Tanaka is still working on these bluer roses today. Since the delphinidin is clearly not sufficient, he is trying many other routes: adding genes from gentian that modify the delphinidin, and genes from the genus *Torenia* that produce copigments. In a nod to Willstätter, he is even trying to change the pH value in the rose petals.

Tanaka is confident he will develop a bluer rose before his retirement, only five years away. But after spending thirty years on this project, he has also learned to be cautious: "It is hard to say how blue they will be."

THE DEVIL'S DYE

Scientists may not have solved the riddle of the blue blossoms quite yet. But there is another organic pigment from plants, a blue, that humanity decoded and conquered long ago: indigo.

The sound of the word is rich with the echoes of distant plantations and times long gone. Its history does indeed go far back. In Peru, researchers have found cotton fabrics dyed with indigo that are around six thousand years old. And when, in the pigment archive of the Dresden University of Technology, I held in my hands a featherlight block of indigo, it seemed thrillingly exotic. On the other hand, I was standing there in jeans—trousers that get their color from precisely the same pigment. The story of how the world went from one form of the pigment to the other is also the history of the chemical industry.

In Europe, a wild-growing plant called woad was already supplying indigo a thousand years ago. Julius Caesar reported on it in *The Gallic Wars*: "All the Britons, indeed, dye themselves with woad, which produces a blue colour, and makes their appearance in battle more terrible." (In *Braveheart*, Mel Gibson appears as the Scottish freedom fighter William Wallace in blue war paint, but that's just Hollywood. The film takes place in the thirteenth century, and at that time the custom had been out of date for hundreds of years.) The connection between the blue pigment and the barbarians did not make indigo particularly popular with the Romans.

However, they saw a different blue as a luxury item. They believed it was made from stones, and since it mostly came from India, it was given the name "indigo." In reality, the substance came from plants of the species *Indigofera*, shrubs that are indigenous to the tropics. And the pigment derived from it was the same as that produced by woad.

In Europe, the color blue was all the rage in the Middle Ages. The red dyers, who had been favored until then, slowly lost their position, and despite all attempts to bring blue into disrepute

In the Middle Ages, such lumps of indigo were traded for a lot of money.

(including a request to color the devil blue in the future), woad quickly became the most important dye plant. At the time, indigo was the only way of coloring clothes and materials blue, and the substance was traded as "blue gold." In Germany, dyer's woad was cultivated primarily in Thuringia. The plant made some farmers into "woad barons" and brought high tax revenues to some towns. The wealth of the city of Erfurt was based on woad; in France, the area around Toulouse profited from it.

But woad had only a brief heyday. After Vasco da Gama discovered the sea route to India, importing indigo from overseas became much cheaper than growing woad locally. On top of that, production soon started in the New World. Huge indigo plantations were set up in Guatemala and the Antilles, for example. There the work was done by slaves, and their exploitation made the sought-after blue even cheaper.

Germany resisted the competition for local production of the pigment. The pigment from the "Indian flowers" was denigrated as a "pernicious, damaging corrosive dye." The Imperial Police Ordinance of 1557 banned its import and use: "so that such a Devil's dye will be entirely avoided by the drapers." Other cities issued similar bans and threatened harsh punishments. In France, possible punishments even included the death penalty. But it was a losing battle. *Indigofera* bushes delivered up to thirty times as much indigo as woad, and the Thirty Years' War, which broke out in 1618, further weakened the local woad industry. The last woad mill in Europe closed down in 1820, and from then on nature's blue was only imported.

But to call indigo "natural" is not quite correct. Neither the yellow-blooming woad nor the *Indigofera* species contain the pigment indigo. Both produce a colorless precursor, indican, that only a laborious process can turn into the blue pigment.

The first step was in the farmers' hands: They harvested the woad plants and milled the leaves into pulp, which they piled up

in heaps and left to ferment for several weeks. Later they made the pulp into balls of woad, which they then sold on. (In French, these balls were called *cocagne*, and that may be the origin of the French *pays de cocagne* and the English Cockaigne, a land of milk and honey.)

The woad balls were then chopped up, doused with water and urine, and left to ferment once more. The result was yellowish-white leucoindigo, a precursor of indigo, which is soluble in water and therefore good for use in dyeing cloth. The textiles were soaked in a leucoindigo bath. When they were put out in the air afterward, the leucoindigo would oxidize, losing two hydrogen atoms and forming the blue pigment, insoluble in water, that's known as indigo.

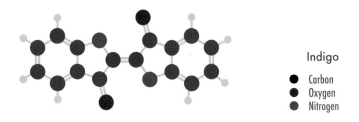

Indigo
● Carbon
● Oxygen
● Nitrogen

I was able to watch the process once in an indigo museum outside Toulouse (there, indigo is called *pastel*). It is an impressive sight: With a pair of tongs, a young woman who had guided visitors around the exhibition fished a rag out of a murky vat of leucoindigo. After a few seconds in the air, the dirty white fabric turned a deep blue. (This may also be the origin of the German expression *blaumachen*, literally to "make blue," which means to skip work. After all, during this last step you have absolutely nothing to do.)

Indigo has another special characteristic. The pigment's molecules stick to the cotton fibers, but unlike other pigments, they do not bind chemically with them. So while the pigment is not washed out, it diminishes with each washing as some molecules are lost, which is how the popular faded jeans look came about.

If you buy a pair of jeans today, it is unlikely that its color derives from a plant. Today, indigo usually comes from chemicals.

RAINBOW REVOLUTION

In 1826, the twenty-year-old chemist Otto Unverdorben conducted a simple experiment with indigo: He mixed the blue pigment with lime and heated it. The result of this "dry distillation" was a colorless oil he called crystalline. Three years later, he inherited his parents' general store and gave up research. He had no idea how important the substance he had made was going to be.

Eight years after Unverdorben developed crystalline, the chemist Friedlieb Ferdinand Runge discovered a brilliant blue oil he called kyanol. Then, in 1840, the chemist Carl Fritzsche, while experimenting with indigo, discovered aniline (*anil* is Portuguese for "indigo"). But it was the chemist August Wilhelm von Hofmann who eventually managed to show that these three substances—crystalline, kyanol, and aniline—were one and the same. The name *aniline* prevailed.

The substance itself prevailed as well.

That is because aniline could easily be extracted from coal tar. During the nineteenth century, blast furnaces sprang up everywhere to supply iron, the raw material of industrialization. These furnaces were fueled with coke, and a by-product of the process of turning coal into coke was a black, sticky mass: coal

tar. At first no one knew what to do with this cheap waste product, but it soon turned out there was a whole sea of colors slumbering within it. It was to unleash a rainbow revolution.

In 1856, William Henry Perkin, one of Hofmann's assistants, discovered by chance how a purple pigment could be produced from aniline. Perkin christened it mauveine. Two years later Hofmann discovered, at the same time as other chemists, a red pigment, fuchsine, that could be produced from aniline. And on it went. More and more pigments followed: "Language, indeed, fails adequately to describe the beauty of these splendid tints. Conspicuous among them are the crimsons of the most gorgeous intensity, purples of more than Tyrian magnificence, and blues ranging from light azure to the deepest cobalt. Contrasted with these are the most delicate roseate hues, shading by imperceptible gradations to the softest tints of violet and mauve."

The tar colors caused a sensation at London's International Exhibition of 1862. Even Hofmann himself seemed surprised to see how "a diversity of novel colours allowed on all hands to be the most superb and brilliant that ever delighted the human eye" could be developed from tar: "a black, sticky, fetid semifluid equally repulsive to sight, smell, and touch." The tar colors became the most important product of the burgeoning chemical industry. Even today, that can be seen in the names of some major corporations: BASF is short for Badische Anilin- und Sodafabrik (Baden Aniline and Soda Factory), AGFA for Aktiengesellschaft für Anilinfabrikation (Corporation for Aniline Manufacturing). The rainbow revolution was celebrated as a victory over nature: "The production of pigments has been taken away from Mother Nature and handed over to the chemist. The radiant luster of his products surpassed everything nature offered freely."

Ironically, indigo itself, the "king of dyes" and the original source of aniline, resisted all attempts to produce it synthetically.

Only in 1878 did the German chemist Adolf von Baeyer finally succeed in this. And it took the company BASF many more years to develop production on an industrial scale and at a reasonable cost. In the summer of 1897, "pure indigo BASF" finally came on the market.

The project had consumed the (in those days) immense sum of 18 million marks, more than the company itself was worth. But it paid off. Synthetic indigo sold like hotcakes and soon supplanted the botanical product. In 1895, natural indigo valued at 21 million marks was still being imported, but that had dropped to 1.8 million marks by 1905. In that year, BASF and Hoechst—which was, by then, also producing the synthetic blue—sold synthetic indigo at a value of 20 million marks.

Indigo is still produced in large quantities today: around fifty thousand tons per year. Most of that is used to dye billions of pieces of denim clothing (a pair of jeans takes just a few grams). The process creates enormous amounts of toxic waste products, however.

Scientists in California have figured out how indigo could be produced using bacteria, a process that would be far less harmful to the environment. As a model, they used another plant that was employed in Japan to produce indigo: dyer's knotweed. The plant produces an unstable precursor of indigo—called indoxyl—and then stabilizes it by attaching a glucose molecule to form indican. Scientists taught bacteria to do the same: They genetically altered *E. coli* to produce indoxyl and then added a gene from dyer's knotweed, which allows the bacteria to attach a glucose molecule to the indoxyl. The resulting molecule, indican, is excreted by the bacteria. Indican is stable in the air and is therefore easy to store and transport.

Here's the scientists' idea: An item of clothing is initially sprayed with the indican liquid, then with a liquid containing

an enzyme that removes the protective sugar molecule. On the clothing, the indican turns into indoxyl, then indigo. In a study published in 2018, the scientists demonstrated the process on a shawl. Whether it can be used at an industrial scale is another question, of course.

And whether consumers will want such a product is yet another question. Even though indigo has always been a chemical product as much as a natural one and is made mostly by the petrochemical industry today, many people might find an indigo produced by genetically modified bacteria particularly unnatural. And nowadays, unnatural tends to mean undesirable. That wasn't always the case. In fact, when BASF put their new indigo on the market, other companies attacked the product by casting doubts on whether it was truly synthetic. One of their competitors, Bayer, circulated a letter claiming that BASF's indigo "is nothing other than natural indigo in a certain prepared form and has absolutely nothing in common with artificial indigo." Today, this attack would be seen as advertising.

In the early twentieth century, the chemical industry developed a plethora of organic blue pigments: molecules that are not produced by any living organism but are assembled out of the same components as plant pigments. As in the evolution of colors in the plant world, little accidents and deviations played an important role. They brought about new products, some of which were successful. The chemical industry had turned into a flower, producing its own pigments.

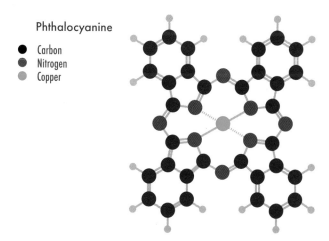

Phthalocyanine
- ● Carbon
- ● Nitrogen
- ● Copper

In 1928, scientists in a Scottish dye factory noticed that a blue powder was occasionally formed during the production of the white chemical phthalimide. Their investigation eventually led to an astonishing discovery: Because there was a crack in the inner glass lining of a steel container, the chemicals sometimes came into contact with iron and formed the blue substance.

The pigment had all the qualities one could desire: It was easy to produce and had a strong color that was long lasting. As early as 1929, the company started commercial production of the pigment: phthalocyanine.

It was five years later that scientists worked out the formula, and it happened to be similar to that of chlorophyll. Humanity had found a new blue, and today it is almost as ubiquitous as the green of the leaves. Phthalocyanine is probably the most widespread blue dye; it is used for printing as well as for varnishes, and to color plastic. Even the metal drinks machine I saw on my arrival in Japan had most likely been colored with this organic molecule.

CHRYSANTHEMUMS

I visited one more laboratory in Japan. About 37 miles (60 km) northeast of Tokyo is Tsukuba, a city that the Japanese government developed into a science and research hub in the 1970s. It is the home of the National Agriculture and Food Research Organization, among other institutions. One of the scientists there, Naonobu Noda, has succeeded in turning chrysanthemums blue.

Noda's strategy was sophisticated: He wanted to implant not only the delphinidin gene of the butterfly pea into the chrysanthemum, but another gene as well, one that would allow the plant to attach a molecule of sugar onto the delphinidin's additional oxygen atom. His hope was that the plant would then attach other chemical groups to this sugar, producing a genuine, deep blue.

His plan worked. But when Noda examined the blue flowers, he discovered that the chrysanthemums did not attach any additional chemical groups to the glucose molecule. The sugar alone had been enough to make the delphinidin merge with the copigments that were already present in the flowers. Chance had helped. Naturally Yoshikazu Tanaka, who was part of the project, has tried to do the same with roses, but once again the roses are resisting. It is almost as if the roses, after all their adaptability over hundreds of years, have decided to draw the line at the color blue.

Noda takes me into an annex where he has kept a few chrysanthemums refrigerated for me. The same questions keep circling inside my head: Does it make sense to expend all this effort and horticultural high tech to create new flowers when countless species are dying out all around us without us even noticing? Then again: Why say anything against it? Isn't it the continuation of what breeders have been doing for centuries?

There are no blue chrysanthemums in nature. But Japanese scientists have succeeded in dyeing the flowers blue with the help of genetic technology.

I'm not a fan of cut flowers. Displaying living beings in a vase in order to watch them die seems a bit odd to me, even in purely aesthetic terms (though I should add that in my hands most plants are doomed to die, and my apartment is a bit of a horticultural hospice).

Yet there is one thing I can't deny: The blue chrysanthemums Noda takes out of the fridge and puts on a low table in front of me are beautiful. Stunning. They are deep blue, and the fact that they have the butterfly pea to thank for their color does not bother me at all.

I let the blue have its effect on me; I try to see this special flower simply as a beautiful thing.

On the way back to the train to Tokyo, I think of the retinal in the cones of my retina. We owe it to this plant molecule that we are able to see colors at all. Perhaps it is only fair that, in return, we have taught chrysanthemums how to be blue.

BLUE

No	Name	Color	Animal	Vegetable	Mineral
24	Scotch Blue		Throat of Blue Titmouse.	Stamina of Single Purple Anemone.	Blue Copper Ore.
25	Prussian Blue		Beauty Spot on Wing of Mallard Drake.	Stamina of Bluish Purple Anemone.	Blue Copper Ore.
26	Indigo Blue				Blue Copper Ore.
27	China Blue		Rhynchites nitens	Back Parts of Gentian Flower.	Blue Copper Ore from Chessy.
28	Azure Blue		Breast of Emerald-crested Manakin	Grape Hyacinth. Gentian.	Blue Copper Ore.
29	Ultra-marine Blue		Upper Side of the Wings of small blue Heath Butterfly.	Borrage	Azure Stone or Lapis Lazuli.
30	Flax-Flower Blue		Light Parts of the Margin of the Wings of Devil's Butterfly.	Flax flower.	Blue Copper Ore.
31	Berlin Blue		Wing Feathers of Jay.	Hepatica	Blue Sapphire.
32	Verditter Blue				Lenticular Ore.
33	Greenish Blue			Great Fennel Flower.	Turquoise or Flour Spar.
34	Greyish Blue		Back of blue titmouse	Small Fennel Flower.	Iron Earth.

Blue da ba dee da ba die . . .

—EIFFEL 65

Werner's Nomenclature of Colours, which
appeared in 1814, was one of the first
attempts to standardize the names of colors.

Should aliens ever land on Earth and try to divine the meaning of *blue* from the English language, it might drive them mad.

Just like the diversity of our planet's species, the variety of our vocabulary has not developed according to some preordained plan. Stimulated by whim and wit, ever-new word variants proliferate, and what eventually gains acceptance does not always fit together: Horror is horrific, but that does not make terror terrific. If olive oil is made from olives, then what about baby oil? *Bimonthly* can mean either twice a month or once every two months. And *biweekly* can likewise mean twice a week or once every two weeks. Which means that sometimes *bimonthly* and *biweekly* can mean the same thing. Though probably just once in a blue moon.

Language is treacherous, and rarely more so than when people talk about colors—especially blue. If you're blue, it means you're sad, and that's where the term *the blues* comes from. But what if someone expects a rosy future? Blue skies ahead. Blue movies are profane, but blue laws are puritanical. A blueprint is a plan, but something you haven't planned for comes out of the blue. In her stunning show *Nanette*, the Australian comedian Hannah Gadsby made fun of the fact that blue is often described as "masculine" and "reliable": "Blue, if anything, is a feminine color. It really is full of contradictions."

It doesn't get better if you look at other languages. In English, people wait until they are blue in the face, but in German people wait "until they turn black." A black eye, on the other hand, is called a "blue eye" in German. In Portuguese you can be blue with hunger. In German, being blue means you are drunk. And in Belgium, being blue of someone means you are infatuated with them. I guess it is possible to be hungry, drunk, and in love at the same time. And maybe that's a good reason to feel blue. But color me confused.

Whatever the ambiguities and contradictions in our use of color words, we can't manage without them. In his 1956 essay "Die Bedeutung der Sprache beim Umgang mit Farben" (The meaning of language in dealing with color), the German linguist Helmut Gipper wrote that a physicist could indeed define light with a wavelength between 440 and 490 nanometers as blue. But even then, he would only have described how far the color word seemed to extend to him or other people, "with nothing said about the inner justification of that value or the degree of its binding nature." Or, as Wittgenstein wrote about another color (but could just as well have said of blue): "How do I know that this colour is red? It would be an answer to say: 'I have learnt English.'"

Where do these color words come from? Why do we have names for these specific colors and not for others? And what does it mean when a language has no word for blue, for instance? Do we have to assume that people who speak that language cannot see that color? Do they just lack the word, or the perception? It was precisely that question that was posed by a famous British politician in the nineteenth century.

BLIND TO BLUE

William Ewart Gladstone had two passions: politics and classical antiquity. Politics became his profession. In 1832, at the age of twenty-two, Gladstone was elected to the British House of Commons. He left Parliament sixty-three years later. During that time he served four times as Queen Victoria's prime minister.

But Gladstone was also a scholar with an exceptional love of Homer, who founded "the sublime office of the poet, and who built upon his own foundations an edifice so lofty and so firm that it still towers unapproachably above the handiwork not only of common, but even of many uncommon men." In his monumental *Studies on Homer and the Homeric Age*, Gladstone examined in more than 1,700 pages everything from "The Sense of Beauty in Homer: human, animal, and inanimate," and his "perception and use of Number," to "Homer's Perceptions and Use of Colour."

And what Gladstone had to say about Homer's colors was certainly intriguing: On closer inspection, Homer's sense of color seemed more than a little odd.

Gladstone painstakingly combed through every passage of the *Iliad* and the *Odyssey* in which a color appears, and his analysis is still impressive today: According to his study, the most frequently used words are *black* and *white*, *light* and *dark*. All other color words are much rarer, and they are employed for things of totally different appearances. With the word *phoinix* (φοίνιξ), Homer describes both the blood pouring out of the wounded Menelaus and also a horse. It would be difficult to explain that even if one translated it as "chestnut brown," Gladstone writes. The difficulty becomes even greater when the same word is used for a young palm tree. Homer uses the word *chloros* (χλωρός), or "green," for twigs, an olive-wood club—and honey.

Blue doesn't appear at all. With the word *kuanos* (κύανος), which later on means blue, Homer characterizes dark things: a dark cloud, the mourning garments of Thetis, Poseidon's hair, and Zeus's eyebrows. But it's also used for objects made of bronze. The word *oinops* (οἶνοψ), which means "wine-colored," is used eighteen times by Homer to describe the sea. But the only thing the sea has in common with wine is that both are dark, Gladstone writes. And Homer uses the same word when talking about oxen.

This evidence brought Gladstone to a surprising conclusion: "Homer's perceptions of the colors of the rainbow were as a general rule vague and indeterminate." The great Greek poet had clearly divided the world mostly into light and dark. Gladstone saw as overwhelming proof of this the fact that in the sky, "Homer had before him the most perfect example of blue. Yet he never once so describes the sky."

Gladstone saw only one possible reason for this: "that the organ of colour and its impressions were but partially developed among the Greeks of the heroic age." The Greeks, Gladstone maintained, simply couldn't see the blue of the Aegean.

COLORFUL THEORY

Gladstone's provocative idea inspired others, especially in Germany. The philologist Lazarus Geiger examined countless sources and announced that Homer was no exception. In other classical texts, too, the color blue was barely mentioned at all. Even the Bible found "no opportunity" to mention the color blue. And Geiger says of the Rig Veda, a collection of hymns and the oldest sacred text of Hinduism, "These hymns, consisting of more than 10,000 lines, are nearly all filled with descriptions of

the sky. Scarcely any other object is more frequently mentioned; the variety of hues, which the sun and dawn daily display in it, day and night, clouds and lightnings, the atmosphere and the ether, all these are with inexhaustible abundance exhibited to us again and again in all their magnificence; only the fact that the sky is blue could never have been gathered from these poems by any one who did not already know it himself."

Another German, the ophthalmologist Hugo Magnus from Breslau, eventually developed a kind of scientific theory about how humans' color perception developed. Magnus believed that the human retina was initially capable of distinguishing only light and dark. It was only through constant stimulation by light that the retina slowly developed the ability to distinguish colors. "We conceive of it this way: That the capacity of the retina was gradually enhanced through rays of light constantly and incessantly striking it," he wrote. Magnus believed that in this development the retina followed the order of the colors of the rainbow.

Gladstone gratefully accepted this theory and shared it. "The starting-point is, an absolute blindness to colour in the primitive man," he wrote. Then the perception of colors awoke at one end of the spectrum: red, orange, yellow. That explained the exceptional importance of the color red in early painting and in the clothing of antiquity. And it also explained Homer's strange description of the world, for he had lived during that period of human development. It was only later, he said, that humans had started to distinguish green shades. Eventually, "in the fourth stage of the development, we find an acquaintance with blue begin to emerge." But that stage was not yet completed, Gladstone cautioned, pointing to reports "that in Burmah a striking confusion between blue and green is a perfectly common phenomenon."

Magnus saw the reason for this sequence in the "vital force" inherent in the different colors. In brief: Red light was particularly full of energy and so had managed to make

itself felt first on the retina. Then the other colors of the rainbow had gradually followed. Magnus thought that our development had not yet been concluded. "We are rather inclined to believe that in the course of coming times our color sense will go through a further period of training and extend beyond the extreme violet end of the spectrum, that is visible today, into the range of the ultraviolet."

The whole theory was saturated in the racism of its time. The development of humanity was routinely described as a slow progress toward perfection, and for the supposedly civilized scholars, many so-called primitive races were seen as being at intermediate stages in this march toward full humanity. Gladstone, for instance, cited as one piece of evidence "the preference, known to the manufacturing world, of the uncivilised races for strong, and what is called in the spontaneous poetry of trading phrases loud, colour."

SPEECHLESS

Gladstone, Geiger, and Magnus were not the only ones who thought this way. In the middle of the nineteenth century many great intellectuals were convinced by the theory. The philosopher Friedrich Nietzsche wrote in *The Dawn of Day*: "How differently from us the Greeks must have viewed nature, since, as we cannot help admitting, they were quite colour-blind in regard to blue and green." Others, too, helped spread the theory. "For a whole decade it remained one of the favorite subjects for a gripping newspaper article, to tell the readers that the Greeks were totally incapable of appreciating the magnificent blue sea on their coast and the splendor of their deep-blue sky," the pharmacist and writer Ernst Ludwig Krause lamented in an 1880

article in the popular magazine *Die Gartenlaube* ("The garden arbor"). "A host of superficial philosophers have been indulging in the idea that the sense of color is one of the higher mental faculties that has only slowly found expression in humans."

Krause, one of the most important popularizers of the works of Charles Darwin in Germany, also listed in his article the reasons why he thought Magnus's theory was nonsense. First, there was the fact that untold numbers of animal species can distinguish between colors. How could the human eye have acquired this ability only a few thousand years ago when even bees were capable of it? There was also extensive evidence that the Greeks had painted with blue, and had admired lapis lazuli most of all. "Since, however, the stone doesn't glitter, or shine nor is it transparent, it can only have been praised for its color," Krause wrote.

Today there are other things that seem suspect to us. We know that the long-wave rays of light at the red end of the spectrum have less energy than the shortwave light at the blue end. Magnus's theory posited the exact opposite. His ideas about evolution were totally wrong as well. Magnus's explanation is like the story of giraffes developing their long necks by craning them to reach higher and higher treetops. In reality, acquired characteristics are not passed on to subsequent generations. If the retina was actually made more sensitive to color by light striking it, every generation would have to start from scratch. But Darwin's theory of evolution was in its very early stages at that time. His book *On the Origin of Species* was published in 1859, one year after Gladstone's epic volume. Darwin did correspond with Gladstone and Krause, but largely kept out of the debate around color vision.

Krause and other critics did accept that the lack of blue in the *Iliad* and the *Odyssey* demanded an explanation. But it was much more likely, they argued, that it wasn't the perception of color but the words for color that had developed slowly. And

they pointed out that this could be investigated by examining other languages.

Indeed, some scientists were soon setting off to look into which colors people in other cultures could name and which they could perceive. For example, the German doctor Rudolf Virchow examined a group of Nubians that Carl Hagenbeck, a merchant who dealt in wild animals, had literally put on display at the Berlin Zoological Garden. (Such "anthropological-zoological shows," as Hagenbeck called his spectacle, were no rarity in those days and were intended to show the "stages of development" of humanity. With his investigations into head shapes and color words, Virchow covered this racism with a scientific veneer.) All the results pointed in one direction, wrote Rudolf Hochegger, one of Magnus's critics, in 1884: "The investigations into the color sense of primitive peoples have shown clearly that a separate sensibility for all colors can be present, even if the linguistic expression is lacking."

Initially, Magnus refused to accept that. Together with scientists at the Museum of Ethnography in Leipzig, he designed a questionnaire investigating to what degree "the uncivilized tribes perceive colours and distinguish them by names like civilized nations." With the support of doctors and missionaries, he had numerous ethnic groups in Africa and Asia interviewed, as well as the Sioux in North America and the Latvians in Europe. The result of all this was sobering for Magnus. The South African Ovaherero, a pastoral tribe in Africa, had plenty of words for the colors of their cattle. "They have no words for colors that do not occur among their beasts, in particular blue and green, although they can distinguish them from the others and, if necessary, use foreign words." Many of them even found it "very ridiculous that there should be words for those colors."

The conclusion was obvious: Magnus admitted that one could not deduce an ethnic group's sensitivity to color from

the words they had for colors. And yet he refused to rescind his theory of the gradual development of the color sense: "On the contrary, even now we still hold on to this theory under all circumstances," he wrote.

Yet without a body of evidence, the arguments made by Gladstone, Geiger, and Magnus collapsed. The results were clear: It was not the eye that had developed gradually, but language. It was a question of human culture, not anatomy. The debate, it seemed, was over. But a few decades later, the color spectrum would once again become an intellectual battleground. Again it was about the differences between cultures. And again it was about the color blue.

BLEEN

When Paul Kay was studying anthropology in the United States in the 1950s and '60s, one thing was considered incontrovertible: Every language can divide up the spectrum into colors as it sees fit, independently of every other language. "There is no such thing as a 'natural' division of the spectrum. Each culture has taken the spectral continuum and has divided it into units on a quite arbitrary basis," the anthropologist Verne Ray wrote in 1952.

If that were true, it ought to be pretty difficult to translate colors from one language into another. For where Americans see blue and green, people speaking a different language might see five different colors—or just one. They might conflate orange and yellow into one color, subdivide red into a dozen shades, or combine half of the red range with a quarter of violet into a color all its own.

The adherents of this view frequently based it on the work of philologist Benjamin Whorf and his teacher Edward Sapir.

Their theory of linguistic relativity, often called the Sapir-Whorf hypothesis, made two assertions: that different languages represent reality in different ways, and that these representations in turn influence the way people see the world. In short: The language we speak influences—possibly even determines—the way we see the world.

Although Sapir and Whorf had never written about color words themselves, the color spectrum had become a prime example of their hypothesis. If Geiger and Magnus had prematurely concluded that a lack of color words indicated some difference in human biology, the supporters of Sapir and Whorf turned that on its head. For them, the differences in language were not an indication that the eye was seeing something different. Language itself was a kind of mental eye through which humans could see the world in different ways.

For the work on his doctorate, Kay went to Tahiti, researching social structures in the capital, Papeete. He also learned Tahitian and was surprised how well most color words corresponded to English ones. There was one exception: Tahitian had only one word for what in English would be either *blue* or *green*—*bleen*, so to speak.

After returning to the States, Kay met Brent Berlin. Berlin was a linguist and had learned Tzeltal, the language of the Maya people, in Mexico. To their surprise, the two of them discovered that they had had exactly the same experience. The words for color in Tzeltal, like those in Tahitian, were surprisingly easy to relate to those in European languages, apart from one difference: There were no separate words for blue and green.

At that time Kay and Berlin had no idea that some of Gladstone's contemporaries had already been struck by the same observation. The Leipzig ethnologist Richard Andree had written in 1872: "There does however remain one striking fact that is yet to be explained, namely that there are numerous peoples

scattered all around the world who conflate blue (black) and green and have one single expression for them."

Kay and Berlin decided to get to the bottom of this. First, with the help of some students, they questioned people who spoke twenty different mother tongues. Initially they tried to determine the "basic color terms" of each language: color terms that were not combinations (such as *sky blue*), did not come from a foreign language (such as *ecru*), did not refer to a particular source (such as *salmon pink*), and were in general use. After they had found these basic color terms, the researchers asked the participants to indicate on a large color chart which area corresponded to each of these colors and which was the best example of the color. In addition to these twenty languages, Kay and Berlin found data for seventy-eight other languages in the literature, which they also included.

In 1969, a slim volume presenting their conclusions, *Basic Color Terms: Their Universality and Evolution*, was published. Different languages did indeed have a different number of basic color words, Kay and Berlin wrote. While some languages had only two or three such words, in English there were eleven: *black, white, red, yellow, green, blue, brown, purple, pink, orange*, and *gray*. But the division of the color spectrum did not seem to be at all arbitrary. There was astonishing agreement between the speakers of most languages when they were asked to indicate the best example of a color. Languages with fewer color words did indeed divide the spectrum up more broadly, but they still had boundaries occurring in the same places as languages with more color words—they just had fewer boundaries. It was as if the spectrum had predetermined breaking points at which it was most likely to divide into different colors.

And there was one additional pattern that Kay and Berlin found: Languages with only three color words generally

distinguished between black, white, and red. Yellow and green tended to come next. Only after that was blue named as a color in its own right. It was the same order that Geiger had suggested following his study of classical sources.

THE WORLD OF COLORS

The book by Berlin and Kay sparked the debate about colors once more. Did people who speak different languages distinguish colors largely in the same way after all, and was there really regularity in the way colors were named? While many psychologists quickly accepted the results of the study, some anthropologists vehemently opposed them. "We attacked a dogma that wasn't just accepted but also popular," Kay told me when I visited him in Berkeley, almost fifty years after his book appeared. "Even today, there are still people who accuse us of pursuing murky imperialist goals."

Many critics pointed out weaknesses in Kay and Berlin's work: The researchers had examined only twenty languages and had interviewed only a single person for some of these. Most participants could also speak English. Wasn't it possible that their knowledge of the English color words influenced what they said in their mother tongue? On top of this, seventeen of the twenty languages Kay and Berlin investigated came from industrialized societies with a written language. Would the results really be the same with a larger sample of languages from very different cultures? Some scientists pointed to languages that did not seem to obey Kay and Berlin's model. A much larger data set was needed. And Berlin had an idea how to get that.

In 1934 the missionary and linguist William Townsend founded the Summer Institute of Linguistics. This Christian organization aimed to study indigenous languages in order to help translate the Bible into these languages. Berlin was in contact with Townsend and suggested recruiting the missionaries, who were scattered all over the world, as research assistants. They would each ask twenty-five indigenous people to name a set of 330 colored chips and record the results. This study, which became known as the World Color Survey, actually worked, and in 2009 the researchers presented data from 110 languages—from Abidji in Ivory Coast to Zapotec in Mexico.

In this large sample of languages there were divergences and exceptions, and the boundaries between colors were not exactly the same in some of them. But the data essentially confirmed what Kay and Berlin had already formulated forty years before: There were some areas of the color spectrum that humans gave names to sooner than others. But why?

Scholars have put forward countless hypotheses. Is it something to do with the characteristics of a color? The structure of the eye? The closer to the Equator people live, the stronger the solar radiation, and that can lead to damage of the lens and photoreceptors. The rare receptors for shortwave light, the blue cones, are especially affected. Could that be the reason why several cultures from that part of the world have only a single word for both green and blue?

Or are there cultural reasons? Does the development of the words depend on the dyeing techniques a culture develops? After all, there is much less reason to talk about color when people cannot yet transfer it or use it. As long as everything has its natural color, it is mostly sufficient to talk about the thing itself. Is blue named so late because it is so difficult to find a blue dye, a blue pigment?

A group of researchers working with the neuroscientist Ted Gibson proposed another explanation in 2017: Distinguishing colors at the red end of the spectrum is simply more useful. They started off by dividing the spectrum up into warm colors (red, orange, yellow) and cool colors (green, blue, violet). Then they looked at how the languages that had been examined in the World Color Survey made distinctions within the warm and cool colors. They saw that these languages distinguished between red, orange, and yellow more than between the cool colors. That is not really surprising if one recalls the many examples of languages with a *bleen* instead of *green* and *blue*.

The scientists then examined twenty thousand photos from a Microsoft database. The photos showed animals, people, faces, cars, signs, and other things. People spend more time looking at these things in photos than at the background, and the scientists who had set up the database wanted to use it to train a computer to recognize these objects.

When Gibson and his colleagues analyzed the colors in these photos, an astonishing pattern appeared: The objects in the foreground had mostly warm colors, while the backgrounds had mostly cool colors.

They concluded that words for red and yellow develop first in most cultures because the things that humans communicate about tend to have those colors. "There simply are not that many natural blue objects, which may explain why many languages acquire the term 'blue' relatively late," the scientists wrote in their publication.

Perhaps Gibson's idea is part of the answer; perhaps not. It is quite possible that none of the hypotheses proposed so far are the sole explanation. Fifty years after Kay and Berlin found a pattern in the words for color, the search for the origin of that pattern continues.

DARWIN'S COLORS

We may all broadly agree about what we mean when we say *green*, *red*, or *blue*. But what about finer distinctions? How many of us would agree on exactly what it is that differentiates sky blue, royal blue, and ultramarine?

For most people, that is hardly important at all. But scientists who were exploring the natural world before the age of photography had to agree on some system so they could document in words the colors of the animals, plants, and stones they found. "Measurements, weights, mathematical and chemical formulae, and terms which clearly designate practically every variation of form and structure have long been standardized," the ornithologist Robert Ridgway wrote in 1912, "but the nomenclature of colors remains vague and, for practical purposes, meaningless, thereby seriously impeding progress in almost every branch of industry and research."

On his five-year circumnavigation of the world aboard the HMS *Beagle*, Charles Darwin filled several notebooks with his descriptions. Common among them are almost poetic passages such as that of March 1832, when the *Beagle* was moored off the coast of Brazil. He had "been struck by the beautiful color of the sea when seen through the chinks of a straw hat," he noted. The sea was "Indigo with a little Azure blue," he wrote. "The sky at the time was Berlin with [a] little Ultra marine."

These descriptions of color were based on a book by the German mineralogist Abraham Gottlob Werner. Werner had developed a color system in order to describe minerals more precisely. The Scottish painter Patrick Syme supplemented the work with examples of animals and plants, and it was published in 1814 as *Werners Nomenklatur der Farben* ("Werner's Nomenclature of Colours").

It consists of 110 hand-painted chips, each furnished with a name and examples from the world of animals, plants, and stones. Once more it turns out that blue is special.

Werner's book teems with the names of colors inspired by nature: Red is named after blood, roses, or peach blossoms. There are honey yellow, lemon yellow, straw yellow, and saffron yellow; grass green, apple green, and pistachio green. But the blues take their names almost entirely from art and chemistry: Prussian, Berlin, or China blue; indigo and ultramarine. There is just one name from nature among them: flax-flower blue.

But Werner's book was not enough for many scientists. Ridgway tried to deal with the problem himself, and in 1886 he published a book describing 186 colors. But even his own work did not quite satisfy him, and in 1912 he published a second book: *Color Standards and Color Nomenclature*. This time he described and named 1,115 different colors.

Ridgway's work was influential, and it paved the way for modern color classifications, such as Pantone or the RAL system. Today there are numerous such standardized systems of color. But they can be traced back to the attempts by naturalists to put the world's wealth of colors into words.

In the introduction to his book, Ridgway criticized fanciful names such as "London smoke," "ashes of roses," or "elephant's breath." But the names he gave to blue evoke wonderful associations: forget-me-not blue, smalt blue, capri blue, and cornflower blue. To an English speaker, all these shades belong to the same color: blue. But that is not the case in all languages.

LANGUAGE INSIDE YOUR HEAD

I'm looking at a blank computer screen and thinking: *semicircle, triangle, semicircle, triangle*. Martin Maier told me to pay attention to these two shapes. Thirteen geometrical shapes are about to appear in rapid succession on the screen. Afterward I will

have to answer a few questions: Was one of the shapes a semi-circle? And, if so, was it the top or the bottom half of a circle? And was there a triangle? And if so, was it pointing to the right or the left? *Semicircle, triangle, semicircle, triangle,* I think.

The computer is in a small room at Humboldt University in Berlin-Adlershof. Maier is part of psychologist Rasha Abdel Rahman's research team, and, even though it may not sound like it, he is studying whether the language I speak influences how well I perceive the color blue.

When the exercise starts, I'm surprised at the speed. Each of the thirteen shapes flashes on the screen for a fraction of a second. There's a semicircle—I saw it clearly. Triangle? Negative. The whole sequence is over in less than two seconds. After a couple of turns Maier assesses my results.

I missed a few triangles—ones that came immediately after a semicircle. That's normal, Maier says. Scientists call it "attentional blink." My mind is still occupied with having seen the semicircle, so I don't see the triangle when it appears immediately afterward. But if my mother tongue were not German but Russian or Greek, I would probably have seen more of the triangles.

Maier carried out the study with three different groups in 2017, and the fact that the participants consisted of Germans, Greeks, and Russians was not a matter of chance.

One of Kay and Berlin's mistaken conclusions was that the maximum number of basic color words is eleven, as is the case in English (or German): *black, white, red, yellow, green, blue, brown, pink, orange, purple,* and *gray*. In fact, some languages have twelve basic color words, since they distinguish between light blue and dark blue. In Russian, for example, *goluboy* (голубой) describes a light blue, and *siniy* (синий) a dark blue. There are two words in Greek as well: *galazio* (γαλάζιο), light blue, and *ble* (μπλε), dark blue. Those words are learned by little children and used in everyday life.

The images in Maier's experiment were combinations of two shades of color: for example, a light blue triangle on a dark blue background. But where Germans always saw *blau* on blau, Greeks saw ble on ble or galazio on galazio in some cases, and in other cases they saw a contrast: ble on galazio or galazio on ble. These triangles are the ones that Greeks were more likely to spot than me. Apparently the color contrast that Greeks see in this situation can break through the attentional blink. (The same was true of Russians.) They saw more because they had more distinct categories. In Maier's experiment, it wasn't the Greeks who were blind to blue, but the Germans.

Maier's experiment investigates the second part of the Sapir-Whorf hypothesis: whether the linguistic categories we divide the world into have any influence on how we perceive it. Their study is one of the clearest indications so far that that is indeed the case.

It is not the only one.

In 2007, Lera Boroditsky and her colleagues were examining people whose mother tongue was either Russian or English. Boroditsky wanted to see whether the distinction between goluboy and siniy in Russian meant that Russians were faster than English speakers at distinguishing between shades of blue. Fifty subjects were shown three blue squares like these on a computer screen:

Their task was to decide as quickly as possible which of the two lower squares has the same color as the upper one. Sometimes both choices were light or dark blue. Sometimes one choice was light blue, the other dark. The task was repeated hundreds of times. The analysis showed that Russian speakers were indeed faster at distinguishing between goluboy and siniy than between two blues of the same shade. For English speakers, on the other hand, there was no difference.

The really exciting part was an additional twist. The researchers asked the participants to keep a sequence of eight numbers in their heads during one run-through. When they did that, the difference between Russian and English speakers disappeared. Apparently the part of the brain that allows Russians to better distinguish between blues can be diverted by a linguistic task (keeping the numbers in their heads). It is as if language, when we're not actually using it to speak, supports our vision.

What do these results mean for us humans? Just as seeing colors is a creative process in which our brain compares the signals from three types of cones against each other and against our assumptions about the world, thus producing the colors before our inner eye, speaking is also a creative process. With our words we divide up the spectrum of colors, which our brain generates, and in this way we create order in the jumble of colors. And this order we then practice again and again every time we look out into the world, until we find it much easier to distinguish a blue from a green than a light blue from a dark blue.

Boroditsky and her colleagues wrote in their publication: "The critical difference in this case is not that English speakers cannot distinguish between light and dark blues, but rather that Russian speakers cannot avoid distinguishing them: they must do so to speak Russian in a conventional manner." In some ways Russians and Greeks spend their whole lives practicing the

differentiation between light and dark blue, and it is perhaps no great surprise that they are better at it than Germans, who have to make that distinction less often.

However, Abdel Rahman and Maier's experiment goes further than that. Not only could the Greeks and Russians distinguish more quickly between light and dark blue; they were also more likely to perceive shapes in the two colors. One of the most beautiful speculations on the Sapir-Whorf hypothesis is Ted Chiang's magnificent short story "Story of Your Life" (*Arrival*, the science fiction film based on it, is also worth seeing). In Chiang's story, a linguist learns the language of extraterrestrials who have arrived on Earth. These extraterrestrials perceive the world differently than humans: For them, there is no sequence of past, present, and future, but a kind of coexistence among different times. As the translator learns their language, she also starts to perceive the world a little like the aliens do—and suddenly she can remember the future!

It is a wonderful thought experiment. In reality, language is hardly going to be this powerful. The effects we can demonstrate using the color blue in the lab are interesting but small. The difference that Abdel Rahman and Maier observed between Germans and Greeks in their experiment amounted to a mere 3 percent. That means that if a German overlooks a hundred triangles on average, a Greek overlooks ninety-seven. This can hardly lead to significant differences between Greeks and Germans in everyday life.

And yet.

Many heated debates that I, as a journalist, have had in recent years with friends had to do with the words we choose to use and the specter of political correctness. In these discussions I frequently argued that it was certainly right to choose our words carefully, but that it seemed futile to eradicate racist language without changing the racist attitudes of many people. It would

be like putting makeup over a wound: The problem may not look as bad, but it's still as dangerous as before.

But what if the categories we use when we speak every day, quite without thinking, have an effect on our perception? If they influence the way we see the world at some fundamental level, even if only slightly, then I consider that a strong argument for taking our choice of words even more seriously. In this way, the studies on blue that I have read over the past few years have indeed changed how I view the world.

ANIMALS

A butterfly blue
In the wind's soft sway,
Shimmers in pearly hue,
Then flutters away.

—HERMANN HESSE

The peacock's feathers have a dark blue
shimmer yet contain no blue pigment.

Anyone who's ever seen a blue horse won't soon forget the sight. For me it happened as a teenager during my first visit to Munich. There, in one of the city's famous museums, the Lenbachhaus, I saw Franz Marc's *Blue Horse I* and was immediately struck by the painting. It is a masterpiece of color: In the background is a suggestion of soft hills in red and purple. In the front at the right, a dark green plant is growing. But the painting is dominated by the horse of the title. The animal is standing there, head bowed, thoughtful, almost sad. And blue.

For me, a child of the TV generation who grew up with the neon-green Hulk and a purple cow advertising Milka chocolate, the sight was certainly less shocking than for Marc's contemporaries, who saw the picture over a hundred years ago. Some, it is said, spat at the picture. But even today, the painting possesses an astonishing power, probably in part because blue animals are rare in nature, and blue *mammals* even rarer.

Of course, that doesn't mean there aren't any blue animals. The animal world is full of color, and there are countless examples of impressive blues: birds, beetles, and butterflies; fish, starfish, and dragonflies. Unlike the world of plants, where blue is largely restricted to the blossom, nature has painted animals blue in numerous places. The feathers of the kingfisher are as blue as the wings of the morpho butterfly. The feet of the blue-footed

booby and the tongue of the blue-tongued skink are as blue as their names advertise. Some animals even have blue blood. And male vervet monkeys have a bright blue scrotum, though they hide it in a fold of skin whenever an animal of higher rank is in the vicinity.

We know exactly why Franz Marc painted his horses blue. He wanted to express their inner being this way. "We will no longer paint the forest or the horse the way they please us or appear to us, but the way they really are and the way the forest or the horse feel themselves, their absolute being that lives behind the appearance that is the only thing we see," he noted one or two years after he had finished the painting that now hangs in the Lenbachhaus. While there was a whole range of blue pigments Marc could have drawn on to color his horse, they are almost unknown in the animal world. Instead, nature has found another ingenious solution. When it comes to blue, animals' appearances really are deceiving, the color a kind of cheat. One of the first people to understand this was a scientist who lived in London in the seventeenth century, and even though he is as impressive as his contemporary Isaac Newton, his name isn't as well-known.

FANTASTICAL COLORS

Robert Hooke was a genuine universal genius. Interested in both the cosmos and the microcosm, he discovered the red spot on Jupiter and coined the word *cell* after looking at a piece of cork under a microscope. Hooke invented innumerable devices, discovered the law of elasticity that is now named after him, examined fossils, and developed some of the first ideas about biological evolution. After the Great Fire destroyed large parts

of London, Hooke was part of a commission to rebuild the city, surveying much of the land himself and designing new buildings. Beyond that, he was a gifted visual artist, a talent he employed in one of his most famous works, the book *Micrographia*, which appeared in 1665.

In that book, Hooke showed how countless things look under the microscope: a razor blade, some mold, frozen urine, a flea, or the compound eye of a fly. Galileo and others had already used the microscope some fifty years earlier to enlarge tiny objects. But Hooke's detailed drawings, many of which folded out, amazed his contemporaries. "The most ingenious book that ever I read in my life," Samuel Pepys noted in his diary, itself destined to become one of the most important documents of those times.

Hooke was also interested in the rich colors of the animal kingdom, and so one day he placed peacock feathers under his microscope and described exactly what he saw: from the feather's shaft, barbs lead off to either side, and from each barb, in turn, little barbules lead off to either side. Hooke realized that these barbules carry the color—which looked no less magnificent under the microscope than with the naked eye. Depending on the angle he observed them from, the barbules seemed to be shimmering with different colors.

But Hooke also made an astounding discovery: If he put water on the feather, its shimmering color vanished. As soon as the water had evaporated, it reappeared. The peacock's colors were, Hooke concluded, "onely fantastical ones." He deduced that "the beauteous and vivid colours of the Feathers of this Bird, [are] found to proceed from the curious and exceeding smalness and fineness of the reflecting parts." He was right, though he could hardly suspect how small those structures really are.

Above: The beetle *Pseudomyagrus waterhousei* owes its color to tiny balls of chitin in its scales. They are arranged in such a way that they reflect only blue light.

Bottom left: The blue sea snail *Glaucus atlanticus* feeds on jellyfish, among other things.

Bottom right: The tails of younger blue-tailed skinks are believed to attract the attention of predators away from the more vital body parts and can be shed in an emergency.

In April 2018, I was sitting in a conference center in Cambridge, England, with about a hundred scientists from all around the world. Outside the clouds hung low and gray, while inside I witnessed a parade of the most magnificent, colorful living beings: metallic blue fruits, bright green beetles, golden moths, and algae shimmering like living opals. Living Light was the name of the conference, and it had attracted Hooke's intellectual heirs: biologists, physicists, and materials scientists who were investigating how living beings create colors without any pigments.

After Hooke's investigations, almost three hundred years passed before researchers possessed microscopes powerful enough to see the structures he had only guessed at. Today it is clear that many colors in the animal world—especially its beautiful blues—come about in a fundamentally different manner from the way they arise in plants. Flowers generally carry pigments that absorb a portion of visible light and reflect the rest. Which is not surprising, given that plants live off sunlight and so learned early on to capture that light with pigments.

The blues in birds, beetles, or butterflies, however, are mostly produced by tiny structures that bend, scatter, or reflect rays of light. For these structures to interact with light, they have to be roughly the same size as the wavelengths of visible light: a few hundred nanometers. Microscopically small grids and stacks, ridges, rods, and balls reflect the light waves in such a way that some of them extinguish one another, and what remains is one particular color. The colors that Hooke discovered are called "structural colors" today. They come from tiny structures that are mostly colorless themselves, and they are among the most beautiful things nature has produced. They are indeed fantastical colors.

THE SOAP BUBBLE PRINCIPLE

In the summer of 1898, the painter Henri Matisse was walking around Paris when, in a shop window opposite the Louvre, he saw a collection of butterflies that included a particularly impressive blue specimen: "But what a blue: a blue that went straight to the heart!" he told the art critic Pierre Courthion decades later. He didn't really have the money for such luxuries, but he bought it anyway.

It was probably a specimen of *Morpho*, a group of butterfly species that live in the Amazon rain forest, among other places, and have been hunted for hundreds of years because of their beauty. There are many different species that are designated morpho butterflies. Their wingspan can be up to about 5 inches (12 cm), and they have a striking bouncing flight. But the most remarkable thing about them is the luminous blue on the wings of the male. It ranges from the delicate light blue of *Morpho godarti* to the deep blue of *Morpho rhetenor*.

Matisse was not the only person to be captivated by the beauty of these creatures. The author and butterfly researcher Vladimir Nabokov once described them as "shimmering light-blue mirrors." Their name, *Morpho*, comes from a surname for the Greek goddess of beauty, Aphrodite. The animals are not only one of the most beautiful examples of structural color, they are also one of the best examined.

To understand how a morpho butterfly produces its color, it helps to look at a much simpler example of structural color: the shimmering colors of a soap bubble. When sunlight hits the surface of the bubble, a part of it is reflected right there, at the border where the air and the soap bubble meet; another part penetrates into the layer of soap solution and is then reflected on the other side of that layer, where the soap bubble meets the air inside. This light has traveled a little farther, and so it

is lagging behind the part of the light that was reflected at the bubble's surface. The two light rays overlap, but because one traveled farther than the other, they are slightly out of alignment with each other.

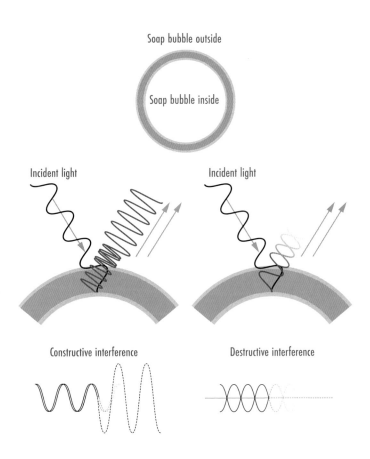

Soap bubble outside

Soap bubble inside

Incident light

Incident light

Constructive interference

Destructive interference

What happens now differs for the different wavelengths—that is, the different colors—contained in white light. In some wavelengths, the two rays' crests coincide and the color intensifies. In other wavelengths, crests in one ray coincide with troughs in the other ray, so they cancel each other out and the color disappears. Scientists call this interference. The same effect happens in a film of oil on water: One part of the light is reflected off the surface of the oil; another part penetrates it and is reflected by the water beneath it. The way the light from these two reflections interacts is what creates the colors; these are called interference colors. The same phenomenon makes a soap bubble shimmer in different colors in different places.

Nature has exploited the things that happen by chance in a soap bubble and perfected them over millions of years. One creature in which the simple soap-bubble principle can be observed is the giant wasp *Megascolia procer javanensis*. It lives in Java and Sumatra, and with a wingspan of up to about 5 inches (12 cm), it is one of the largest wasps in the world. The surface of its wings has a blue-green shimmer, and scientists have been able to show that the shimmer is caused by a single transparent layer of chitin on the surface of the wings, just three hundred nanometers thick. You don't have to travel to Indonesia to see this effect, however. The shimmering green-violet color on the neck of the common rock pigeon comes about in a very similar way.

In most cases, instead of one thin layer of a given substance, nature has stacked many thin layers, one above the other. It's as if soap bubbles were nested inside each other, like Russian dolls. Made with nanometer precision, these tiny reflecting layers can control the light in such a way that one specific color is seen from most angles. That is what happens in the morpho butterfly.

To the naked eye, the morpho's wings look like a uniform shimmering blue surface. But zoom in a little bit and you can see that the wings consist of up to a million tiny overlapping scales. At slightly higher magnification, a pattern of ridges can be seen running parallel to each other along the whole length of the scale. If you zoom in even closer, these ridges dissolve into what look like long rows of Christmas trees. These tiny trees are only about a micrometer in size, and they are the main reason for the enchanting color of the morpho butterfly. Light is reflected by the individual layers of these "trees," and in this process blue light is amplified and the other colors extinguished.

The blue of the morpho butterfly is created by tiny structures shaped a little like Christmas trees that are arranged on the surface of its wings.

Engineers envy such structures, and for years they've been trying to create similarly brilliant structural colors. In October 2017, a few months before the Living Light conference in Cambridge, the car manufacturer Toyota announced that, after years of intensive work, they had succeeded in copying the color of the morpho butterfly. The company offered one of its sports

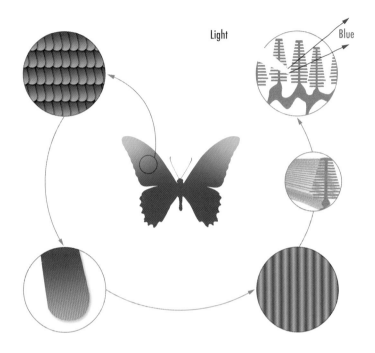

cars in an exclusive Structural Blue Edition. Originally, Toyota said, forty separate layers of material had been necessary to create the shimmering blue, but eventually they were able to reduce that number to eight layers. It took around three hundred billion tiny slivers of pigment to color each car.

It is absurd to celebrate the beauty of the butterfly on a sports car of all things, a luxury product that is basically a symbol of the recklessness with which humans are destroying the environment. But it is also a good example of the enormous effort it takes to capture or copy some of nature's beauty, a reminder of how fascinating the nature of colors is. Or, as Homer Simpson would say, "Whoa, a blue car!"

LIVING OPALS

The microscopically small Christmas trees of the morpho fascinate me as much as the blue they create. Like Hooke's drawings from the seventeenth century, the electron microscope images of the butterfly's wings are a window on a miniature world, and the structures they reveal are no less impressive than the most beautiful cathedrals. No wonder, then, that in Cambridge one scientist after another showed photos of them in their presentations.

Stacking ultrathin layers one on top of the other is just one trick that animals have perfected to create a radiant blue. There are other microscopic marvels as well—tiny, highly ordered structures that produce the coveted color.

Some beetles have developed photonic crystals. The scales on the back of the blue longhorn beetle, *Pseudomyagrus waterhousei*, are filled with tiny transparent balls of chitin, the same material its exoskeleton consists of. These spheres are only around two hundred nanometers in size—one thousand times smaller than a human hair is thick. And they are closely and regularly packed, like hundreds of transparent tennis balls that have been tipped into a chest. When light strikes these spheres, part of it is reflected by the uppermost layer of spheres; a part passes through these spheres and is then reflected by the second layer of spheres; another part is reflected by the third; and so on. Like the light from different layers of the morpho's Christmas trees, these light rays overlap one another, creating interference colors.

The same principle gives the gemstone opal its play of colors. In the opal, this is thanks to tiny balls of silicon dioxide—microscopic glass spheres. Many colorful beetles are essentially living opals. In some insects, the technique has evolved even further. Instead of packing little balls together, they build a latticework that encloses spherical cavities. In this case, the tiny spheres are balls of air—a kind of inverted opal.

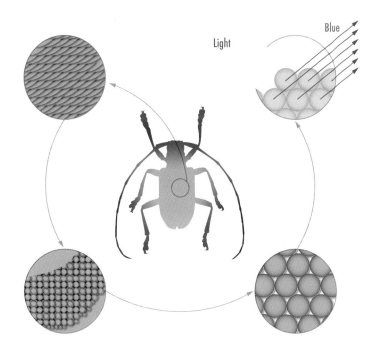

The shimmering colors of the peacock, which Hooke had studied, arise from a similar arrangement. Directly under the surface of the feathers' barbules lie several layers of melanin rods, like tree logs stacked at the side of a road. It is this regular arrangement of rods that bends the light in such a way as to create color. The distance between the different layers determines the color. In the place where the feathers appear green, the rods are slightly farther away from each other, and where the feathers appear blue, they're somewhat closer.

SPONGY BLUE

To really grasp how structural colors are created, one needs to understand more physics and mathematics than I do. But after listening to dozens of lectures at the Cambridge conference and talking to several scientists there, one principle did become clear: It takes a precisely calibrated balance between order and disorder to produce the perfect blue. On the one hand, there are the patterns of lamella, balls or rods that are repeated regularly and bend or break the light; and on the other hand, there are tiny flaws, deviations, and inaccuracies that are just as important.

For example: If a morpho butterfly's rows of Christmas trees were all the same height, the color of its wings would change much more dramatically when observed from different angles. Because the neighboring rows are of different heights, however, the blue becomes more stable, and the wings appear azure from many angles.

In theory, a structural color can arise without any molecular order at all. Take blue eyes. The sole pigment in the iris, the circle of color around the pupil, is the brown-black melanin that also colors our hair. All humans have some melanin in the one-cell-thick layers at the back of the iris, the pigment epithelium. There, the rays of light are absorbed so that light can enter the eye only through the pupil. But in front of the pigment epithelium is another layer, called the stroma, and the amount of pigment in it determines the color of the eye. The eyes of people who have a lot of melanin in the stroma appear brown. People with blue eyes have only a little melanin there. That means that long-wave red portions of light traverse the stroma and are then absorbed by the pigment epithelium. The blue light, which has shorter waves, is scattered more, some of it so much that it leaves the eye again. In principle, it is the same process that makes the

sky appear blue. But the particles in the eye that scatter the light are much larger than the molecules in the air.

It's easy to reproduce this effect at home by putting a few drops of milk into a glass of water and shining the beam of a flashlight through it. The milk forms little drops of fat in the water, which scatter the light from the flashlight. Blue light is scattered more readily than red, and so the liquid in the glass appears blue.

For a long time, many of the shades of blue in the animal kingdom were explained by this scattering effect: the blue of dragonflies, as well as the blue of the blue jay and other birds. It was not until the arrival of the electron microscope that it was possible for scientists to examine feathers more precisely. In Berlin in 1939, Helmut Ruska put the blue feathers of an ivory-breasted pitta under a Siemens Super Microscope. It was the first electron microscope in the world, developed by Ruska's brother Ernst, who was awarded the Nobel Prize for it in 1986, almost five decades later. Ruska and the zoologist Fritz Frank wanted to see the mysterious "blue structure." What they found was a "spongy, honeycomb-like microstructure" of keratin, the substance birds' feathers are made of, as well as hedgehogs' spines and our fingernails and hair. Not much can be made out in the grainy black-and-white image they published as proof, but nowadays there are wonderful photos of this spongy structure. Kingfishers, blue jays, purple-breasted cotingas: They all have this porous matrix of keratin in the barbs of their blue feathers.

By now it is clear that this structure is by no means as random as it appears. Instead of simply scattering light, as the molecules of air in the atmosphere do, there is a kind of order hidden here. Unlike the balls of chitin in the blue longhorn beetle, which are always identical, the cavities in the keratin matrix do not resemble a box full of tennis balls as much as a bag full of popcorn.

Even though they look disordered, the spaces are all of a similar shape and size, and if the shape and size is just right, then that's all that's needed to create the impression of blue. Only the color doesn't shimmer any longer. Mostly, it seems dull.

A LOOK INTO THE PAST

A few months before I attended the conference in Cambridge, I was already in Britain, following the trail of structural color to Kew Gardens in London. There, botanist Paula Rudall was waiting for me with a little glass bottle from the gardens' huge archive of plants. She opened the bottle, and with a pair of tweezers took out the tiny shoot of a plant. The leaves had lost their green and taken on the transparent brown of papyrus. But at the

The shiny blue of the marble berry is composed of countless little dots of varied hues.

tip, a dozen or so small berries glistened a bright metallic blue, as fresh as if they had only just been picked. A note in the flask gave the place and time of the plant's collection: Ethiopia, 1974.

Pollia condensata, also called the marble berry, is a shrub that grows across large parts of Africa. And it was the incredible intensity of the berries' hue that initially gave Rudall and other biologists the idea that it might be an example of a structural color. The physicist Silvia Vignolini, who chaired the conference I would attend in Cambridge later that year, has decoded the origin of the color: The surface of the berry consists of cells with thick walls, and these walls consist of layers of tightly packed cellulose threads. Each layer is rotated slightly with respect to the one below it, creating a kind of spiral, and that arrangement allows it to reflect blue light more than any other. But not only that: Each cell on the surface of the marble berry creates a slightly different color, and it is out of these innumerable tiny dots that the captivating blue is composed, like the water of the Seine in a pointillist painting by Georges Seurat. Even if structural colors are much rarer in the plant world than in the animal world, some plants have mastered the trick. And because the arrangement of cellulose in the marble berry doesn't change over time, its color doesn't fade either.

The stability of structural colors is one of their most intriguing characteristics. The sight of the shining *Pollia* berries was almost uncanny. While pigments lose their intensity after just a short time, or disappear completely, the tiny structures that create interference colors can be preserved over years—millions of years. If Giovanni Verri's method of using infrared light to make Egyptian blue visible after thousands of years is impressive, then what structural colors can do is spectacular—like finding technicolor videos from ancient Greece.

The paleontologist Maria McNamara studies structural colors in fossils. She is especially interested in insects. At the conference in Cambridge, McNamara gave a presentation on her work, and one of her slides was titled "The Problem of Blue." On it, about a dozen petrified beetles—millions of years old—were shown, all of them shining a magnificent blue. The problem: While there are countless blue fossils to be found, hardly any of these creatures' living relatives are blue. Most scientists studying the color blue in nature wonder why it is so rare. McNamara had the opposite problem: Why was blue so common in these animals? Had the insects changed their color in the course of evolution? Or was the blue not their real color, but a consequence of fossilization?

McNamara has an unusual approach to answering these questions: She re-creates the conditions under which an animal is petrified. In a small apparatus in her lab, McNamara exposes beetles to pressure and temperatures similar to what the fossils have withstood, and then examines the result through the electron microscope. In this way, she has been able to solve the puzzle of blue: While they're alive, the beetles generate their colors through a series of thin layers of material, similar to the way the peacock's feathers produce blue. Through the pressure that occurs during the process of petrification, these layers are pressed closer to one another, creating a shift in the wavelength of light they reflect and turning green beetles into blue ones. Many a fossil that appears blue today wasn't blue at all when it was a living creature.

That leaves one more question to be answered—and it is one that has been discussed since Darwin's time: Why did all these glorious colors evolve in the animal kingdom? That question has led to plenty of fierce arguments among scientists, and also laypeople, and occasionally even among painters and politicians.

PEACOCK IN THE WOODS

Abbott Handerson Thayer was a successful painter. Trained in New York and Paris, he initially painted mostly landscapes. Later, he was celebrated for his portraits—he painted Mark Twain and Henry James, among others. But he was also an eccentric and a hypochondriac who insisted that his family sleep outdoors year-round to avoid disease. His mood fluctuated between "all-wellity," as Thayer put it, to euphoria and depression. Today he would probably be diagnosed with bipolar disorder. Back then, Thayer himself simply called it the "Abbott pendulum."

Even though Thayer was an artist, he has earned a place in the history of biology as the "father of camouflage." That is because he discovered something important, a "beautiful law of nature," which he described as follows: "Animals are painted by nature, darkest on those parts that tend to be the most lighted by the sky's light, and vice versa."

In his 1909 book *Concealing-Coloration in the Animal Kingdom*, which Thayer wrote together with his son Gerald, he explained the phenomenon using a black-and-white photo of a white hen in front of a white background. You might think that a white animal in front of a white background would be almost invisible. But color alone is not enough to disguise it. Since the light comes from above, the lower part of the animal is shaded and stands out dark against the white background. Thayer realized that most animals are colored in a way that exactly reverses this gradient: They are bright on their belly and dark on the back. Since this shading perfectly counteracts the shading caused by sunlight, the animal appears flat, making it more difficult to be seen: better camouflaged.

Today, scientists call the effect Thayer observed countershading, and it is indeed widespread in the animal kingdom.

But Thayer extended his theory further—much further—maintaining that all colors in the animal world serve as camouflage. The red of flamingos, he claimed, was camouflage when set against the red sunset at dusk, the time of day when the animals were in the most danger. Even in the striking blues

Find the bird: The artist Abbott Thayer was convinced that the colors of the peacock were intended to camouflage it in the woods.

of the animal kingdom he saw an opportunity for animals to conceal themselves. The shimmering blue on a peacock's neck had developed because it rendered the bird invisible against the blue of the sky, he imagined, and to prove his point, he painted a picture called *Peacock in the Woods* for his book's title page. In it, the peacock's tail disappears in the green of the leaves, and its head in the blue of the sky.

Thayer's book triggered loud dissent. And among the loudest critics was a man who only a short time before had been the most powerful man in the world: Theodore Roosevelt. Roosevelt had been president of the United States from 1901 to 1909, and—unhappy with the direction the Republican Party was taking—would go on to found a new party and stand for election again in 1912. In the meantime, he became involved in a public argument with Thayer about colors in the animal kingdom.

Roosevelt was an enthusiastic amateur naturalist, if not an animal lover in the modern sense. After his second term in office, he had gone on a yearlong expedition across Africa. In an appendix to a book about this journey, which appeared in 1910 and became a bestseller, he listed 164 species of mammal he had shot: rats, apes, lions, leopards, gazelles, giraffes, rhinoceroses, and more.

In another appendix, entitled "Protective Coloration," he delivered a harsh judgment of Thayer's theory. Thayer, he wrote, had extended his idea to outrageous extremes; Roosevelt listed numerous examples. After Thayer rejected Roosevelt's criticism as "the nearest to one hundred percent of error that I have ever read," Roosevelt responded with a long article in which he stated that Thayer's ideas were "untenable," "absurd," and "preposterous." "What I would like to get is a serious study by a competent scientific man," the former president wrote in another letter.

Roosevelt's criticism was brutal. For example, he had a go at Thayer's frontispiece. Not only was the blue of the sky chosen to match the blue of the peacock exactly, he said, but "the peacock is accordingly portrayed under conditions under which he probably would not be seen once in a thousand times." And Roosevelt's reaction to Thayer's explanation of the blue jay's color was no better. In his book, Thayer depicted the magnificent blue bird in winter, disappearing in a bluish shadow in the snow. "This winter I carefully studied the blue jays in my neighborhood," Roosevelt wrote. "The enormous majority of the shadows, in fact all that I saw during the winter, were not blue shadows of the color of a blue jay's plumage." And if they had been, "they would have been out of harmony with every other winter bird, with the far more numerous snow birds, for instance." On top of that, blue jays lived mainly in areas where it never snowed. Thayer's argument was, Roosevelt wrote, like putting a raven in a coal scuttle in order to prove that its black feathers served as camouflage.

Even though Thayer had, in his arrogance, overshot the mark, his discovery of countershading is still recognized today. His ideas were used by the US Navy to camouflage ships in the First World War. And he sharpened biologists' eyes to the fact that even colors that didn't look like camouflage could serve as camouflage. Even blue.

Vast numbers of sea creatures are blue on top and a light color on their underside. That is true of many species of tuna and for sharks such as the mako. And some of the most beautiful inhabitants of the sea, those that drift on the surface and are sometimes called the "blue fleet," are white and blue. Among these are the Portuguese man-of-war, a very poisonous jellyfish that's known in Australia as the bluebottle; and the blue button, *Porpita porpita*, which looks like a jellyfish but is really a colony

of cnidarians. And then there is the beautiful blue sea slug *Glaucus*, which feeds on the other two animals.

Some sea creatures have taken countershading one step further and even produce blue light to disguise themselves. Firefly squid have tiny organs scattered across their body that produce blue light. This way, the squid, which hunts at night, is difficult to see from below because it blends into the moonlight dappling the surface of the water. For the same reason, the squid *Euprymna scolopes*, which lives off the coast of Hawaii and hunts shrimp at night, takes in the bacterium *Aliivibrio fischeri*, which produces light for it.

While *Peacock in the Woods* was not an especially convincing explanation for blue as camouflage, the image of a squid in the sea is quite convincing. But Roosevelt was probably right. Most blues in the animal kingdom did not develop to blend in with the surroundings, but to attract attention.

BLUE POISON

The splendor of color in the animal world occasionally caused Charles Darwin problems. In February 1867, he was preoccupied with caterpillars. Some bear a remarkable resemblance to a twig or a leaf, and according to Darwin's theory of natural selection, the reason was obvious: Those caterpillars that were more difficult to recognize had a survival advantage and were more likely to produce offspring—thus, their camouflage would improve from generation to generation.

But other caterpillars advertise themselves in bright colors. It seemed to Darwin that that could hardly confer a survival advantage, and at the same time it could not be a strategy to attract females, since caterpillars are not sexually mature and

only mate as butterflies. In his despair, he asked his fellow naturalist Alfred Wallace for advice in a letter: "Why are caterpillars sometimes so beautifully and artistically coloured?"

Wallace's reply arrived promptly the following day: Some caterpillars were presumably equipped with an unpleasant taste that was meant to spoil predators' appetite. "It would be a positive advantage to them never to be mistaken for any of the palatable catterpillars, because a slight wound such as would be caused by a peck of a bird's bill almost always I believe kills a growing caterpillar." The answer left Darwin ecstatic. "I never heard any thing more ingenious than your suggestion & I hope you may be able to prove it true." In fact, Wallace had immediately suggested asking the naturalist John Jenner Weir to test his theory. Weir was a customs official, but also an enthusiastic amateur naturalist with a keen interest in insects. And he kept a multitude of birds in a large aviary. It would be easy for him to investigate Wallace's idea, for if it was correct a clear pattern should emerge: Insect-eating birds would tend to avoid vividly colored caterpillars and would instead consume caterpillars camouflaging themselves in drab colors.

Weir carried out the experiments conscientiously and reported the results two years later. It was as Wallace had suspected: All the green or dull caterpillars were devoured by the birds, but brightly colored caterpillars, such as the blue-and-yellow larvae of *Diloba caeruleocephala*, the figure of eight moth, were spared. The case was the same with caterpillars that featured striking hairs or stings: "None of these species were even examined by the birds, and were permitted to crawl about the aviary for days with impunity."

Typical warning colors tend to be the long-wavelength colors such as yellow and red, often contrasting with black: the fire salamander with its black-and-yellow skin; the yellow-and-black

stripes of hornets, wasps, and bees; the black, red, and yellow patterns of poisonous coral snakes.

Very few people think of blue as a warning color, but there are at least a few creatures that signal their toxicity with the color. A few poison dart frogs, for example, are colored a luminous blue. And then there is the blue-ringed octopus, one of the most poisonous of all sea creatures. Off the coast of Australia or Indonesia, it normally lives well camouflaged on the seabed. But when it feels threatened, about sixty shining blue rings on its skin start pulsating. Three other closely related species of octopus carry a similar blue pattern and react the same way. All four can inject the extremely powerful nerve poison tetrodotoxin with their bite. It is the same poison that occurs in puffer fish, a Japanese delicacy whose preparation demands great skill

The poison of the blue-ringed octopus is extremely dangerous. As a warning to predators, the octopus makes the blue rings on its skin pulsate.

from (and confidence in) the cook. One thousandth of a gram of the poison is sufficient to kill an adult. It is not the octopus itself that produces the poison, but bacteria living in its intestines.

A few years ago, scientists finally discovered how the creatures make their skin flash. The rings are made of cells with densely packed parallel plates, arranged so that only blue wavelengths are reflected, a little like the morpho butterfly's wings. Directly on top of these blue cells lie muscle cells in the skin that can be tensed, pulling darker cells over the blue ones like a curtain, so that the color is no longer visible. The octopus can make the rings pulsate by quickly contracting and relaxing those muscle cells.

Almost every example of blue as a warning color is hotly debated. A few years ago, scientists in the United States were wondering whether blue could serve as a warning color at all. In order to find out, they used a hundred quail chicks, offering them mealworms under tiny paper tents. The tents were decorated with parts of butterfly wings that were either blue, orange, black, or blue-orange. From birth, the chicks avoided food that was put under an orange or a blue-orange tent, but ate from under the blue and black tents. But when the researchers made the mealworms under the blue tents unpalatable by marinating them for twenty minutes in a solution of mustard powder, the young birds learned to avoid the blue tents.

So even if animals may not be hardwired to recognize blue as a warning color, they can learn to avoid blue. And the color can arouse much attention. It seems that some animals use it not to frighten off predators but to divert them. Many lizards have a blue tail when young, for instance. These animals can shed their tails when danger threatens, and it naturally helps if the predator then concentrates on the disposable body part and not on the rest of the lizard.

Japanese scientists have studied lizards of the species *Plestiodon latiscutatus*. On the islands where the reptiles' predators were mostly weasels and snakes, the lizards had the most striking blue tails. On islands where they were preyed upon mostly by birds, they had developed a brown "camouflage" tail instead. Why? The birds see so well that they can probably distinguish between tail and body, in which case it is better not to stand out at all.

A SENSE OF THE BEAUTIFUL

Even if blue can sometimes serve as camouflage, and in other cases as a distraction or a warning, many of the most extravagantly colored animals are neither poisonous nor well disguised. Why, for instance, should a bird with long, vibrant blue feathers, which make it easily recognizable and hinder it when flying, outlive birds of the same species that have less striking plumage? This was another puzzle that brought Darwin to despair. Just seeing a feather from a peacock's tail made him sick, he wrote in a letter in 1860.

But Darwin did find a solution for this conundrum eventually, and he presented it in his second great book: *The Descent of Man, and Selection in Relation to Sex*. It deals above all with sexual selection, the second principle Darwin considered a driving force of evolution, alongside natural selection. Darwin had realized that for an animal to pass on its genes, being adapted to its environment wasn't enough. It had to do more than find food and defend itself against predators. It had to be successful with the opposite sex. Survival was one thing, leaving behind descendants another.

Sexual selection helped explain a whole series of phenomena that were difficult to understand through the lens of natural

selection alone. There were those adaptations that helped animals, mostly males, to best their rivals in the struggle for the opposite sex: for example, the imposing antlers of a stag or a stag beetle. Other adaptations were directly aimed at winning over the opposite sex—such as the magnificent plumage of a bird of paradise or a peacock.

The sense of beauty was frequently attributed to humans alone, Darwin wrote, but "when we behold a male bird elaborately displaying his graceful plumes or splendid colours before the female, whilst other birds, not thus decorated, make no such display, it is impossible to doubt that she admires the beauty of her male partner."

The idea that simple animals, and females at that, could compare the beauty of various individuals and then make a decision was going a step too far for many people in Victorian England. Even Wallace, Darwin's brother-in-arms, rejected the theory. Darwin, on the other hand, would not be deterred: "If female birds had been incapable of appreciating the beautiful colours, the ornaments, and voices of their male partners, all the labour and anxiety exhibited by the latter in displaying their charms before the females would have been thrown away," he wrote. "And this it is impossible to admit."

As a result of this ongoing debate, sexual selection wasn't studied nearly as much as natural selection for many decades. And yet Darwin had posed a fascinating question: Why should a female indigo bunting prefer a particularly blue male? Darwin himself thought that there may be no right answer to that: "Why certain bright colours should excite pleasure cannot, I presume, be explained, any more than why certain flavours and scents are agreeable," he wrote. But there has been more research into sexual selection in recent years, and scientists have found a few possible answers to Darwin's question.

The blue of the indigo bunting (above) and the blue jay (below) is a structural color.

HONEST SIGNALS

One of the animals Darwin was able to observe on the Galápagos Islands was the blue-footed booby. This large bird is an accomplished diver. It flies over the sea until it finds a shoal of little fish, such as anchovies, then plunges down into the water from dozens of feet above to catch the fish. But on land these birds are rather awkward.

When male blue-footed boobies vie for females, they launch into an elaborate courtship dance. They strut on the spot, lifting their blue feet so the female can admire the color. This blue comes about through two mechanisms: layers of collagen in the skin that create a structural blue, and yellow pigments embedded in the skin. Together, they produce a luminous turquoise, and female blue-footed boobies are crazy about that turquoise. When scientists used makeup to paint male blue-footed boobies' feet pale blue instead, those males had less sex with their mates than boobies that had not had their feet painted. Even if the birds had already coupled and laid an egg, the change in foot color still caused a reaction in the females: Those pairs' second egg was on average smaller than that of other pairs.

The female's foot-color fetishism is not without reason. Studies have shown that the color of the feet of blue-footed boobies is influenced by their diet. The turquoise of males who were not given food faded within two days, and that of males who were fed fresh fish shone more intensely. Apparently the carotenoids in their food are the necessary ingredient for the pigment in their feet, and thus for the turquoise.

Scientists call that an "honest signal," for the blue-footed booby can produce the bright turquoise color only if it has eaten enough food—signaling that it could also provide for offspring.

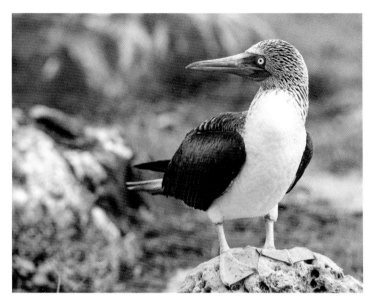

When male blue-footed boobies want to win over a female, they proudly present the blue of their feet.

It is not so different from a person driving an expensive sports car, since they can't afford the car unless they have the money (or, nowadays, a credit card and questionable priorities).

What is true of the booby's feet is also true of the feathers of the blue grosbeak. The bird breeds in the southern United States and northern Mexico. Researchers investigating the grosbeak in the 1990s were able to show that in autumn, when they are growing new feathers, the best-fed birds have the bluest plumage. And a further study showed that the birds with the bluest plumage not only live in the largest territories with the greatest abundance of prey, but also provide their offspring with the most food.

The same principle is at work in both cases. Male birds that are more successful in finding food have access to more resources that make their feet or wings shine more intensely.

The blue is a kind of stamp of quality. And some other birds color their surroundings as well as their feathers.

The satin bowerbird, which lives in Australia, is an impressive creature. The females of the species are gray-green to brown on the back and have yellowish bellies. What is most striking about them is the dark blue iris of their eyes. The males, on the other hand, have dark plumage that shimmers a velvety blue-black, and the stronger that blue is, the more successful they are with females (the feathers also reflect very strongly in the UV range, but studies have shown that it's actually the amount of blue that females evaluate).

But when a male satin bowerbird wants to impress a female, he doesn't rely on looks alone. He builds a little bower on the forest floor out of hundreds of tiny twigs and decorates the area with blue objects he's collected: flowers, berries, bottle tops, or plastic waste. Birds that collect more blue items have greater

The blue grosbeak's feathers are also apparently for showing off; they probably signal dominance to other males. The bluer the plumage, the more desirable the territory they control.

success with the females. In fact, scientists were able to turn less attractive males into regular lady-killers by decorating their bowers with extra blue objects.

In contrast, the birds have no patience for red items and immediately try to remove them. Scientists have exploited this aversion to red. They have put red objects in males' bowers and made it difficult for them to remove them—by putting a transparent container over them, for instance, or gluing a red object to a bolt and fixing that in the ground. The birds that were better at solving the problem and hiding or removing the red objects had greater success with the females.

These examples demonstrate that bright colors in the animal world are often about more than mere appearance. A bright blue can impress females because it shows the male is a healthy individual and a good provider; in the satin bowerbird, it can even prove the male's intelligence. The preferences of females of these species would seem to have good evolutionary grounds, then. It is a matter of honest signals: Beauty represents truth. This view has gained widespread acceptance in biology. But not everyone is convinced by it.

DANGEROUS IDEAS

Darwin died eleven years after the publication of *The Descent of Man*. His theory of natural selection continued to circulate after his death; eventually, it penetrated every aspect of biology. But scientists paid little attention to his ideas about sexual selection. One exception was Ronald Aylmer Fisher, a British geneticist and statistician. He combined Darwin's theory of evolution with the burgeoning science of genetics, and in the process also tackled sexual selection.

Fisher had a brilliant insight: Even if a particular type of decorative plumage started out as a signal of good genes, the situation could quickly escalate. The females' preference for the plumage could lead to the evolution of ever more extravagant adornments, even when any benefits these signaled were swamped by their immense cost.

Let us assume, for example, that there is a species of bird in which males with a better immune system have plumage of a more intense blue. Some females have a slight preference for bluer males. They will, on average, mate with healthier, bluer males. Their offspring will inherit their father's healthy immune system and their mother's preference for blue males. And so, over a few generations, these two dispositions—the one for blue plumage and the one for a preference for blue plumage—will become linked, and they will spread together.

At this point, a female with a preference for blue will also tend to bear the hereditary disposition for blue plumage, since her mother has mated with that kind of male. That will lead to two advantages: She will mate with a healthier male. And her male offspring will have bluer plumage, and therefore more success with the females, and will sire more offspring as a result. The consequence: There will be bluer and bluer males and pickier and pickier females. Beyond a certain point, bluer feathers may not indicate a superior immune system, but that will no longer matter. Bluer feathers are now an advantage solely because they are so strongly favored by the females. The honest signal has become an obsession: a blue bubble that will not burst as long as the males' success with the females offsets any disadvantages—for instance, the brilliant blue birds being more easily spotted by predators.

Sexual selection simply careens on. The males become bluer for one reason alone: because the females have a preference for that color. It's beauty for beauty's sake. The biologist and keen

bird-watcher Richard Prum believes that this "useless" beauty has been undervalued and even ignored by scientists. Just as Darwin's Victorian readers refused to accept that wild animals could choose a mate for its prettier plumage, many biologists today refuse to accept that beauty can be entirely without usefulness, Prum maintains. He has presented the arguments for that in his bestseller *The Evolution of Beauty*. In the book he calls this Darwin's "really dangerous idea": that animals might have a sense of beauty that serves no deeper purpose.

Many of Prum's colleagues are skeptical: While, undoubtedly, there are some examples in nature of the craze for beauty that Fisher described, they see these as an exception. In many cases, they argue, other factors probably prevent a preference from escalating into an obsession. Even if Prum turns out to overestimate how common such beauty is for its own sake, he is surely right about one thing: The question of the origin of beauty always involves the question of why we feel something is beautiful in the first place. And so trying to understand beauty in nature takes us back to ourselves: Why do we perceive some things as beautiful? Which of the evolutionary mechanisms that we can identify in other animal species lie at the root of our own sense of beauty? Scientists are only now starting to grapple with that.

What humans see as beautiful is by no means negligible when it comes to the natural world, for besides natural selection and sexual selection, the course of evolution can also be influenced by human intervention. Just as the blue rose, if it ever comes into being, will owe its existence to humans, so many blue creatures owe their existence not simply to a whim of nature, but also to the whims of humans.

BLUE FREAKS

The three budgerigars displayed at a large exhibition of birds in London in 1910 caused a sensation. For the parakeets, which are naturally yellow and green, were in this case blue. *Avicultural Magazine*, the journal of the Avicultural Society, called the trio "perhaps the most startling exhibit" at the event: "In one's early days of bird-keeping one heard of a Blue Budgerigar, but for my own part I never expected that I should ever see one, and probably the majority of us regarded it as a myth."

In fact, at the end of the nineteenth century there had already been reports of an aviculturist from Belgium, a gentleman by the name of Limbach, who had raised a blue budgie. In 1881, L. van der Sinkt wrote to the editor of the magazine *Die gefiederte Welt* ("The feathered world"): "No bird in the world has aroused so much admiration as the blue budgerigar of Mister L. in Uccle." But the wondrous variant had apparently died out, and the creature had been forgotten.

Today, with the help of humans, the blue variant is a rarity no longer. Nature does occasionally produce blue mutants in many animal species. There are regular stories of fishermen in the United States finding bright blue lobsters in their traps. Something like one creature in one or two million is said to have that coloration, though it's not clear what that rough calculation is based on. A few years ago, the source of the blue was identified: As a rule, lobsters have a brown-green-red color that's hard to describe. This color comes mostly from the carotenoid astaxanthin, which is produced by algae and is consumed by many sea creatures. In the lobster's shell, some of the pigment combines with a protein to produce a blue complex. Usually this tint makes up just one part of the shell's color. But the blue mutants produce more of that protein, and their shells are colored almost entirely with the blue pigment, called crustacyanin. Blue

crustaceans are impressive to look at, and so the blue variant of the Florida crayfish, for instance, can be found in pet shops and aquariums all over the world.

With budgerigars, things are different. The birds are native to Australia, and they usually have a yellow face and a green body. In the blue variant, the yellow is replaced by white and the green by blue. That is not mere chance. In nature, green is frequently an ingenious mixture of a yellow pigment and a blue structural color. All that needs to happen for the bird to turn blue is for the yellow to disappear.

Sometimes that can lead scientists astray. That's what happened in 1790, when John White described a newly discovered species of frog. Its name, *Rana caerulea*, came from the most striking characteristic of the frog: It was blue. White was a surgeon in the navy and served on a ship of the First Fleet, which sailed from England to Australia in 1787 to set up a penal colony. White collected quite a few animals there, preserving them in alcohol for later description. In one of these jars was the blue frog, which became the first frog from the new continent to be scientifically described and named.

Only the name was completely wrong. If White had made better notes during his expeditions, he would have been able to avoid an embarrassing mistake. The frog was not blue when it was alive, but green. Over time, the alcohol it was preserved in had destroyed the yellow pigments in the animal's skin, leaving only the blue structural color. But the species name *caerulea*, meaning "blue," has stuck, and in it White's mistake is as well preserved as the structural color of the specimen in the museum.

In living animals such as budgerigars, blue coloring derives from a different kind of mistake: a mutation in the genetic instructions for yellow pigment. In 2017, scientists managed to detect this error in the genome of the blue budgerigar.

For the same reason, mutant blue specimens of all sorts of animals that are usually green occur naturally from time to time—lots of frogs, lizards, and snakes, for instance. Such a mutation is probably less than helpful in nature. But since humans are fascinated by the color blue, it can become an advantage in individual cases. Blue lobsters tend to end up in the aquarium rather than in the cooking pot. In other cases, such beauty can become a curse: The coveted blue of some species has brought them to the edge of extinction.

ENDANGERED BLUE

About an hour outside Berlin, guarded by video cameras and security guards, lives one of the best protected blues in the world: Dozens of parrots about 1.5 feet (0.5 m) long, with sky-blue plumage. The German natural scientist Johann Baptist von Spix described the species in 1819 during an expedition in Brazil, and today it is called the Spix's macaw.

When, on a cold winter's day, I visited the grounds of the Association for the Conservation of Threatened Parrots in Rüdersdorf, Brandenburg, I walked past a long row of cages. Perched in one of the last was a special bird: Lampiao. It was one of the last Spix's macaws that was born in the wild.

Spix's macaws are indigenous to the Caatinga, a region in the northeast of Brazil, where they feed on nuts and build their nests in the hollows of old caraiba trees. At least in theory. In fact, over the years, humans have taken more and more of this habitat. And poachers have hunted the rare creatures and sold them to men (it was always men) who were prepared to fork out ten thousand dollars for a beautiful, unusual animal.

The Spix's macaw was already a rarity when it was discovered. After Spix's expedition, it was eighty years before the parrot was sighted again. And the bird only became rarer and rarer.

At the beginning of 1987 there were only three known Spix's macaws alive in the wild: one mated pair and one male. The pair had produced eggs the previous year and hatched them out, but poachers stole the young shortly afterward. Later, poachers also caught the lone male. All hope now rested on the remaining pair. But on Christmas Eve of that year, poachers captured the female, destroying the three eggs the pair were incubating. They had been the last Spix's eggs in the wild.

But there was a ray of light in that fateful year. In March, police entered a house in Asunción, the capital of Paraguay. Investigators had managed to follow the trail of the last macaw chicks to that house. Arriving in the nick of time, they arrested a woman who was about to flee to the roof with a suitcase. In the suitcase, the investigators found the two young birds. They were going to be sent via Switzerland to West Germany, where a buyer was ready with forty thousand dollars. One of the two chicks was Lampiao.

In his new home in Rüdersdorf, Lampiao is now helping to keep his species alive. For a long time now, efforts have been made to gather the few Spix's macaws living in captivity all over the world for a breeding program, but it kept proving impossible to get agreement among their keepers, and it wasn't until 2004 that a program was finally set up. By then, the last Spix's macaw living in the wild had disappeared. Fewer than fifty Spix's macaws were known in the whole world. From them, a population was to be bred that could one day be released into the wild.

That is not a simple matter. With such a small group of birds, there is always the danger of inbreeding. To prevent this from happening, the genome of every bird is sequenced, and, as far as possible, partners are chosen according to their genetic

compatibility. In practice, this is tedious work, since the birds are extremely picky. But researchers have managed to inseminate the females artificially, an important breakthrough, and now over 140 birds are living in Rüdersdorf; worldwide, there are more than 200.

In 2019, fifty of the macaws were taken to Brazil, where they are adjusting to their new environment in a specially built aviary. They are to be released in 2021.

So there is still hope that the *ararinha-azul*, the "little blue macaw," will one day live in the wild again. But that is by no

The Spix's macaw was first described by the naturalist Johann Baptist von Spix. Today the species is extinct in the wild.

means certain. There are no longer any Spix's macaws that have grown up in the wild. Will the birds know what they have to do to survive? We will have to wait and see.

And the story of the Spix's macaw is only one of many. Our planet is like a color photo that is slowly fading. One shade after another is being lost. The hyacinth macaw is endangered. The blue of the glaucous macaw has already disappeared for good. Other blues have become extinct before we even set eyes on them.

Perhaps we humans ought to take more seriously what the angel says in Hans Magnus Enzensberger's poem "The Visit":

> You cannot imagine,
> he said, how dispensable you are.
> One among fifteen thousand shades
> of the color blue, he said,
> is of more consequence for the world
> than anything that you get up to.

HERE WAS BLUE

I place a delphinium,
Blue, upon your grave.

—DEREK JARMAN

One rainy morning in London a few years ago, I sought shelter in one of my favorite museums, the Tate Modern. I had been thinking about writing a book on the color blue for some time. But on that day I had nothing specific in mind and just drifted through the rooms dedicated to the surrealists, whose works always give me a pleasant little shock and catapult me out of my routine.

And then I was suddenly standing in front of a video that was nothing but blue. A plaque on the wall informed me that it was a work by Derek Jarman; that the filmmaker had been HIV-positive; that as a consequence another virus had attacked his retina, and after that, he only saw the world in blue; that the video was seventy-nine minutes of filmed International Klein Blue.

In the background Jarman talks about his diagnosis, his illness, and tells the story of a boy named Blue. And he says farewell.

> For our time is the passing of a shadow
> And our lives will run like
> Sparks through the stubble.

Jarman died seven months after the premiere of the film.

I stood there, rooted to the spot. It was only a few months earlier that, on a dazzlingly beautiful morning in Berlin-Mitte, a doctor had said to me, "I'm sorry, but I have bad news. Your HIV test was positive."

On that day I had been calm, composed. I'd talked to friends, planned the next steps. But then came the night, and I was alone and there was nothing more to do, and the fear awoke within me. I knew what was happening just then, I could feel it: My blood was teeming with the germs. Millions of virions in every microliter. In my mind they were tiny blue shapes, exquisite machines of a terrible beauty that evolution had formed. And they were replicating, taking me over from the inside. It was the one time in my life when I experienced something like panic—it was like having claustrophobia in my own body.

And now I was in London, standing by this memento mori, and it felt as if everything had led up to this moment and the blue was simply sweeping me away. It was one more moment of absolute blue, the counterpart to that day on the ferry between sea and sky. This time I wasn't hovering between the spheres. Instead it felt as if the world—as if my life—were contracting, smaller and smaller, down to a tiny dot, collapsing into this one moment. As if I were looking into the mirror and the color blue was looking back.

Makes sense, I thought, once I could think again. Makes sense that my search for what I find beautiful ends up bringing me back to myself.

To see beauty is also to see the death it bears within itself. The blue flower withers and fades just as surely as the blue feather will eventually turn to dust. And even the richest blue pigment will lose its luster and pale.

At the same time, it is death that makes beauty possible. The radiant blue of the morpho butterfly is the result of a seemingly endless series of predecessors in which every generation has made way for a new, bluer, more beautiful generation. Life and death, life and death, life and death: That is the rhythm to which evolution plays its tune.

And it is life we have to thank for the blue of many stones. The mountain blue of the azurite, like many other minerals on our planet, could develop only after microorganisms in the oceans started to produce huge amounts of oxygen around three billion years ago.

One of the most beautiful, wisest books I know is Hermann Hesse's *Siddhartha*. There's this passage in which Siddhartha has his awakening: "He looked around as if he were seeing the world for the first time. Beautiful was the world, colorful was the world, strange and enigmatic was the world! Here was blue, here was yellow, here was green."

To see the world like that. The way it is. The beautiful and the terrible. Earth, "small and blue and beautiful in that eternal silence." I only manage that in moments. But they are vast.

One part of me is forever standing on that ferry in Greece, floating in the blue. And another part of me is standing forever in front of that video made by a man doomed to die. And the bridge between those two moments in my life is the beauty of blue.

More than thirty-three million people have died of AIDS. That I am still alive is a credit to modern medicine, which has managed to develop a little pill that I take once a day to keep the virus in check.

For me, science has always made the world more interesting and more beautiful. Now I have it to thank for every moment of beauty I experience.

A lot of time passed that day in the Tate before I left the museum.

When I went out, the sky had cleared.

Here was blue.

FURTHER READING

Andersen, Arne, and Gerd Spelsberg. *Das Blaue Wunder: Zur Geschichte der synthetischen Farben* ("The Blue Wonder: The History of Synthetic Colors"). Cologne: Kölner Volksblatt Verlag, 1990.

Andree, Richard. *Ueber den Farbensinn der Naturvölker* ("About the Color Sense of Primitive Peoples"), in *Zeitschrift für Ethnologie* 10. Berlin: Dietrich Reimer Verlag GmbH, 1878.

Ball, Philip. *Bright Earth: Art and the Invention of Color*. University of Chicago Press, 2003.

Berlin, Brent, and Paul Kay. *Basic Color Terms: Their Universality and Evolution*. Stanford: CSLI Publications, 1999.

Caesar, Julius. *The Gallic War*, translated by H. J. Edwards. Cambridge: Harvard University Press, Loeb Classical Library, 1917.

Celan, Paul. *Der Sand aus den Urnen* ("The Sand from the Urns"). Vienna: A. Sexl, 1948.

Darwin, Charles. Letter to Alfred Russell Wallace (a), February 23, 1867. Darwin Correspondence Project, letter no. 5415.

— — —. Letter to Alfred Russell Wallace (b), February 26, 1867. Darwin Correspondence Project, letter no. 5420.

— — —. *The Descent of Man, and Selection in Relation to Sex*. London: John Murray, 1871.

Dawkins, Richard. *Unweaving the Rainbow: Science, Delusion and the Appetite for Wonder*. New York: Houghton Mifflin, 1998.

Deutscher, Guy. *Through the Language Glass: Why the World Looks Different in Other Languages*. New York: Metropolitan Books, 2010.

Dutton, Clarence. "Crater Lake, Oregon, A Proposed National Reservation," *Science* 7 (1886): 179–82.

Finlay, Victoria. *Color: A Natural History of the Palette*. New York: Random House, 2002.

Flury, Ferdinand, and Franz Zernik. *Schädliche Gase* ("Harmful Gases"). Berlin: Springer Verlag, 1931.

Fontane, Theodor. *Frau Jenny Treibel*. Munich: Deutscher Taschenbuch Verlag, 1998.

Frank, Fritz, and Helmut Ruska. *Übermikroskopische Untersuchung der Blaustruktur der Vogelfeder* ("Examination of the Blue Structure of the Bird's Feather

Under the Electron Microscope"), *Die Naturwissenschaften* 27, no. 14 (April 1939): 229–30.

Gadsby, Hannah: *Nanette* (film). Netflix, 2018.

Geiger, Lazarus. "On Colour-Sense in Primitive Times and Its Development," in *Contributions to the History of the Development of the Human Race*. London: Trübner & Company, 1880.

Gercke, Hans. *Blau: Farbe der Ferne* ("Blue: Color of the Distance"). Heidelberg: Wunderhorn, 1990.

Gibson, Edward, et al. "Color Naming Across Languages Reflects Color Use," *PNAS* 114, no. 40 (September 2017): 10785–90.

Gipper, Helmut. *Die Bedeutung der Sprache beim Umgang mit Farben* ("The Importance of Language in Dealing with Colors"), *Physikalische Blätter* 12, no. 12 (December 1956): 540–48.

Gladstone, William. *Studies on Homer and the Homeric Age*. Oxford: Oxford University Press, 1858.

———. The Colour-Sense," *Nineteenth Century* 2, no. 8 (October 1877): 366–88.

Gnau, Ewald. *Rosen und Dornen in der dreissigjährigen Praxis eines Rosenliebhabers* ("Roses and Thorns in a Rose Lover's Thirty-Year Practice"), in *Rosen-Zeitung: Organ des Vereins Deutscher Rosenfreunde*, 1904.

Goethe, Johann Wolfgang von. *Zur Farbenlehre* ("Theory of Colors"), 1810. Accessed at deutschestextarchiv.de/goethe_farbenlehre01_1810/348.

Hesdüffer, Max. *Berliner Rosenplaudereien* ("Berlin Rose Chats"), in *Rosen-Zeitung: Organ des Vereins Deutscher Rosenfreunde*, 1892.

Hesse, Hermann. *Siddhartha*. Berlin: Suhrkamp, 2017.

Hooke, Robert. *Micrographia*. London: J. Martyn and J. Allestry, 1665.

Huch, Ricarda. *Die Romantik: Ausbreitung, Blütezeit und Verfall* ("Romanticism: Expansion, Heyday and Decay"). Berlin: Hofenberg, 2018.

Jarman, Derek. *Blue: Text of a Film*. Woodstock, NY: Overlook Press, 1994.

Juniper, Tony. *Spix's Macaw: The Race to Save the World's Rarest Bird*. New York: Atria Books, 2003.

Kandinsky, Wassily. *On the Spiritual in Art*, ed. Hilla Rebay. New York: Solomon R. Guggenheim Foundation, 1946.

Kinoshita, Shuichi. *Structural Colors in the Realm of Nature*. Singapore: World Scientific, 2008.

Kipling, Rudyard. *Rudyard Kipling's Verse: Inclusive Edition 1885–1918*. Garden City: Doubleday, Page & Co., 1922.

Klein, Yves. *Overcoming the Problematics of Art: The Writings of Yves Klein*. Thompson, CT: Spring Publications, 2013.

Kraft, Alexander. *Berliner Blau: Vom frühneuzeitlichen Pigment zum modernen Hightech-Material* ("Berlin Blue: From Early Modern Pigment to Modern High-Tech Material"). Diepholz: GNT-Verlag, 2019.

Krause, Ernst Ludwig. *Die "Entwickelung" des Farbensinns* ("The 'Development' of the Sense of Color"), in *Die Gartenlaube/Heft 44*, 1880.

Lee, David. *Nature's Palette: The Science of Plant Color*. University of Chicago Press, 2007.

MacLeish, Archibald. "A Reflection: Riders on Earth Together, Brothers in Eternal Cold," in *The New York Times*, December 25, 1968.

Magnus, Hugo. *Die Geschichtliche Entwickelung des Farbensinnes* ("The Historical Development of the Sense of Color"). Leipzig: Verlag von Veit & Comp., 1877.

— — —. *Untersuchungen über den Farbensinn der Naturvölker* ("Investigations into the Color Sense of Primitive Peoples"). Jena: Gustav Fischer Verlag, 1880.

Marc, Franz. *Schriften* ("Writings"). Cologne: DuMont, 1978.

Matisse, Henri. *Chatting with Henri Matisse: The Lost 1941 Interview*. Getty Research Institute, 2013.

Meinel, Christoph. "August Wilhelm Hofmann—'Reigning Chemist-In-Chief,'" *Angewandte Chemie* 31, no. 10 (October 1992): 1265–82.

Meyer, Rudolf. *Die Blaufarben- und Ultramarin-Fabrikation* ("The Blue and Ultramarine Production"). Quedlinburg/Leipzig: Basse Verlag, 1845.

Meyers Großes Konversations-Lexikon ("Meyer's Large Conversation Lexicon"), sixth edition, vol. 19. Lepizig/Vienna: Bibliographisches Institut, 1909.

Newton, Isaac. *Opticks: or, A Treatise of the Reflexions, Refractions, Inflexions and Colours of Light*. London: William and John Innys, 1721.

Nietzsche, Friedrich. *Morgenröte: Gedanken über die moralischen Vorurteile* ("The Dawn of Day"). Cologne: Anaconda Verlag, 2011.

Nijhuis, Michelle. "The Book That Colored Charles Darwin's World," *The New Yorker*, January 27, 2018.

Novalis. *Heinrich von Ofterdingen*. Stuttgart: Reclam Verlag, 1987.

Pastoureau, Michel. *Blue: The History of a Color*. Princeton University Press, 2001.

Pepys, Samuel. *The Diary of Samuel Pepys*. New York: Penguin Classics, 2003.

Polo, Marco. *The Travels of Marco Polo, the Venetian*, ed. Thomas Wright, 2002. Accessed at public-library.uk/ebooks/60/81.pdf.

Prückner, Christian. *Beiträge zur Kenntnis und Bereitung des Ultramarins, insbesondere in fabrikmäßiger Hinsicht* ("Contributions to the Knowledge and Preparation of Ultramarine, Especially in Terms of the Factory"), *Journal für praktische Chemie*, 1844.

Prum, Richard. *The Evolution of Beauty: How Darwin's Forgotten Theory of Mate Choice Shapes the Animal World—and Us*. New York: Doubleday, 2017.

Ridgway, Robert. *Color Standards and Color Nomenclature*. Washington, DC, 1912.

Roosevelt, Theodore. "Revealing and Concealing Coloration in Birds and Mammals," *Bulletin of the American Museum of Natural History* 30, no. 8 (1911).

— — —. "On the Revealing and Concealing Coloration of Birds: An Unpublished Letter," *The Condor* 26, no. 3 (May 1924): 94–98.

Rosenau, M. J. "Serendipity," *Journal of Bacteriology* 29, no. 2 (January 1935): 91–98.

Rump, Hans Hermann. *Krapp und Ultramarin: Farbstoffproduktion in Pfungstadt zwischen 1767 und 1890* ("Rose Madder and Ultramarine: Dye Production in Pfungstadt Between 1767 and 1890"). Riedstadt: Edition Büchnerland, 2018.

Sander, Gabriele. *Blaue Gedichte* ("Blue Poems"). Stuttgart: Reclam Verlag, 2012.

Schama, Simon. "Treasures from the Color Archive," *The New Yorker*, September 3, 2018.

Schmidt, Helmut. *Indigo—100 Jahre industrielle Synthese* ("Indigo—100 Years of Industrial Synthesis"), *Chemie in unserer Zeit* 31, no. 3 (June 1997): 121–28.

Schöntag, Roger. *Hugo Magnus im Zentrum der Farbendiskussion des 19. Jahrhunderts* ("Hugo Magnus, Key Figure in the Color Terms Discussion of the 19th Century"), *Zeitschrift für Ethnologie* 130, no. 2 (January 2005): 293–316.

— — —, and Barbara Schäfer-Prieß. "Color Term Research of Hugo Magnus," in *Anthropology of Color: Interdisciplinary Multilevel Modeling*. Amsterdam/Philadelphia: John Benjamins Publishing Company, 2007.

Schubarth, Ernst Ludwig. *Verhandlungen des Vereins zur Beförderung des Gewerbefleißes in Preußen* ("Negotiations of the Association for the Promotion of Industry in Prussia"), vol. 4. Berlin: Duncker, 1825

Solnit, Rebecca. *A Field Guide to Getting Lost*. New York: Viking, 2005.

Steiner, Hans. *Vererbungsstudien am Wellensittich* ("Hereditary Studies in Budgies"), thesis at the University of Zurich, 1932.

Thayer, Abbott. "The Law Which Underlies Protective Coloration," *The Auk* 13, no. 2 (April 1896): 123–29.

Theroux, Alexander. *The Primary Colors: Three Essays*. New York: Henry Holt & Co., 1994.

Wallace, Alfred Russell. Letter to Charles Darwin, February 24, 1867. Darwin Correspondence Project, letter no. 5416.

Weir, Jenner. "On Insects and Insectivorous Birds [. . .]," *Transactions of the Royal Entomological Society of London* 17, no. 1 (April 1869): 21–26.

Welsch, Norbert and Claus Liebmann. *Farben: Natur, Technik, Kunst* ("Colors: Nature, Technology, Art"). Heidelberg: Spektrum Akademischer Verlag, 2012.

Willstätter, Richard. "A Chemist's Retrospects and Perspectives," Science 78, no. 2022 (September 1933): 271–74.

— — —. *Aus meinem Leben* ("From My Life"). Verlag Chemie, 1949.

— — —. *Untersuchungen über die Anthocyane. Über den Farbstoff der Kornblume* ("Studies on the Anthocyanins: About the Pigment of the Cornflower"). *Justus Liebigs Annalen der Chemie* 401, no. 2 (1913): 189–232.

— — —. *Untersuchungen über die Anthocyane. Über den Farbstoff der Rose* ("Studies on the Anthocyanins: About the Pigment of the Rose"). *Justus Liebigs Annalen der Chemie* 408, no. 1 (1914): 1–14.

Winawer, Jonathan, et al. "Russian Blues Reveal Effects of Language on Color Discrimination," *PNAS* 104, no .19 (May 2007): 7780–85.

Winckelmann, Johann Joachim. *Geschichte der Kunst des Altertums* ("History of the Art of Antiquity"), 1764.

Wittgenstein, Ludwig. *Philosophical Investigations*. Oxford: Basil Blackwell, 1958.

Young, Thomas. "The Bakerian Lecture: On the Theory of Light and Colours," *Philosophical Transactions of the Royal Society of London*, vol. 92 (1802).

SOURCES

The topic of blue is as vast as the ocean, and it is easy to get lost while exploring it. In this book, I have tried to sail out into it here and there, without losing sight of the shore, hoping in that way to gain a sense of the big picture.

I have used countless sources and talked to hundreds of scientists. Some of the topics I have dealt with are treated in detail elsewhere. Others have been, so far, only discussed in scientific literature. On my website, kaikupferschmidt.de, there is a long list of the books and scientific publications I have utilized. Many are freely accessible online. In the following, I intend to list only the sources of quotations that do not come from personal conversations and give a few pointers to anyone interested enough to plunge more deeply into the blue.

INTO THE BLUE

One of the books that fascinated me as a teenager was Richard Dawkins's *Unweaving the Rainbow*. In it, the biologist answers Keats's criticism of Newton. Reading it helped shape my view of the world, and the beginning is one of the most beautiful passages I have read in a nonfiction book. Steven Pinker rightfully highlighted it in his book on good writing, *The Sense of Style*. *Blue* owes something to both authors.

Many years ago, when I first had the idea for a book about the color blue, a short search immediately turned up a book by Michel Pastoureau: *Blue: The History of a Color*. It's an outstanding book, even if it largely ignores the science of the color blue.

"a peculiar . . . effect on the eye": Goethe (1810)
"The deeper the blue . . . beyond the senses": Kandinsky (1911)
"Colour is . . . a social phenomenon": Pastoureau (2001)
"To see the earth . . . where it floats": MacLeish (1968)

STONES

Lapis lazuli and other beautiful stones have always captured people's imaginations. Given their importance in art, there is a wealth of literature about them. Victoria Finlay's beautiful book on colors, *Color: A Natural History of the Palette*, has a great chapter on lapis lazuli. Philip Ball has written broadly and beautifully on colors, among other places in his book *Bright Earth*, which I discovered in Mas Subramanian's office. Alexander Kraft has written a book on the history of Prussian blue, *Berliner Blau*, which came out after I finished writing this book. However, he examined the pigment's history in several articles that were a big help.

"bluest blue": Schama (2018)

"in which are found . . . azure color": Polo (2002)

"the finest in the world": Polo (2002)

"Since the color . . . the more white it is": Winckelmann (1764)

"In order to make . . . the finest powder": Meyer (1845)

"The water that . . . less beautiful color": Meyer (1845)

"has a most revolting smell": *Meyers Großes Konversationslexikon* (1909)

"What are all . . . a Prussian blue factory?": Fontane (1998)

"Now do you understand Serendipity?": quoted in Rosenau (1935)

"quickly lead to death . . . occurs after 6–8 minutes": Flury and Zernik (1931)

"Death is a master . . . is blue": Celan (1948)

"As the visitor reaches . . . see again": Dutton (1886)

"the bluest blue lake . . . power of analysis": Theroux (1994)

"Hardly any other color . . . as ultramarine": Prückner (1844)

"of sufficient beauty . . . replace ultramarine": Schubarth (1825)

"the discovery of . . . per pound": quoted in Rump (2018)

"I have hated birds . . . beautiful work": Klein (2013)

"All colors bring forth . . . visible nature": Klein (2013)

"the physical sign . . . its immensity": Gercke (1990)

"mineral blue par excellence": Gercke (1990)

SEEING

Color vision is a marvelous process, and there should be more books celebrating this marvel. If you speak German, you'll find much of interest about colors and also about seeing colors in *Farben: Natur, Technik, Kunst* by Norbert Welsch and Claus Liebmann.

"I'm not easily impressed . . . blue car": *The Simpsons*, Season 10, Episode 21, "Monty Can't Buy Me Love"

"Look at the blue . . . at the sky": Wittgenstein (1958)

"the light that got lost": Solnit (2005)

"It becomes necessary . . . yellow and blue": Young (1802)

"As we see . . . draws us to it": Goethe (1810)

"For the Rays . . . that Colour": Newton (1721)

PLANTS

Most books that deal with blue in the plant world are about indigo. Victoria Finlay devoted a chapter in her book to that plant. There is much less to be read about plants with blue flowers. One exception is David Lee's book *Nature's Palette*. I also spent several days in the library in Berlin reading Richard Willstätter's autobiography, and it bears remarkable witness to the tragic life of a scientist.

"Half the world . . . flowers grew": Kipling (1922)

"It's not the treasures . . . the blue flower": Novalis (1987)

"that which everyone . . . I or you": Huch (2018)

"Sixty years have . . . made no progress": Willstätter (1913)

"because of its . . . blue color": Willstätter (1949)

"Therefore this example . . . the cell sap": Willstätter (1914)

"The pigment solutions . . . military hospitals": Willstätter (1949)

"The study seemed to . . . without pain": Willstätter (1949)

"After the war . . . write treatises": Willstätter (1949)

"This is the last . . . for a Jew": Willstätter (1949)

"Much which we sow . . . by others": Willstätter (1933)

"You taught us . . . the laboratory": Willstätter (1949)

"Anyone who could . . . most effective nowadays": Gnau (1904)

"Beautiful roses . . . that is blue": quoted in Hesdüffer (1982)

"All the Britons . . . battle more terrible": Caesar (1917)

"Indian flowers . . . corrosive dye": quoted in Andersen and Spelsberg (1990)

"so that such . . . the drapers": quoted in Andersen and Spelsberg (1990)

"Language, indeed, . . . violet and mauve": quoted in Meinel (1992)

"a diversity of . . . delighted the human eye": quoted in Meinel (1992)

"a black, sticky, fetid . . . sight, smell, and touch": quoted in Meinel (1992)

"The production of pigments . . . nature offered freely": quoted in Andersen and Spelsberg (1990)

"is nothing other . . . with artificial indigo": quoted in Schmidt (1997)

SPEAKING

I first came across Gladstone's work on Homer's sense of color in a book by Guy Deutscher: *Through the Language Glass*. It's a great read. Paul Kay gave me a copy of the book he wrote with Brent Berlin, *Basic Color Terms*, when I went to see him in Berkeley. I was surprised by the book: Inside, it's teeming with color words, but the cover is simply black.

"Blue, if anything . . . full of contradictions": Gadsby (2018)

"with nothing said . . . binding nature": Gipper (1956)

"How do I know . . . learnt English": Wittgenstein (1958)

"the sublime office . . . of many uncommon men": Gladstone (1877)

"Homer's perceptions . . . vague and indeterminate": Gladstone (1877)

"Homer had before . . . describes the sky": Gladstone (1858)

"that the organ . . . the heroic age": Gladstone (1858)

"no opportunity": Geiger (1880)

"These hymns . . . know it himself": Geiger (1880)

"We conceive . . . incessantly striking it": Magnus (1877)

"The starting-point . . . primitive man": Gladstone (1877)

"in the fourth stage . . . to emerge": Gladstone (1877)

"that in Burmah . . . common phenomenon": Gladstone (1877)

"vital force": Magnus (1877)

"We are rather . . . the ultraviolet": Magnus (1877)

"the preference . . . loud, colour": Gladstone (1877)

"How differently . . . blue and green": Nietzsche (2011)

"For a whole decade . . . deep-blue sky": Krause (1880)

"A host of superficial . . . expression in humans": Krause (1880)

"Since, however, the stone . . . its color": Krause (1880)

"The investigations . . . is lacking": quoted in Schöntag (2005)

"the uncivilized . . . like civilized nations": quoted in Schöntag (2007)

"They have no . . . use foreign words": Magnus (1880)

"very ridiculous . . . for those colors": Magnus (1880)

"On the contrary . . . under all circumstances": Magnus (1880)

"There is no . . . quite arbitrary basis": quoted in Berlin (1999)

"There does . . . expression for them": Andree (1878)

"There simply are . . . 'blue' relatively late": Gibson (2017)

"Measurements, weights . . . industry and research": Ridgway (1912)

"been struck by . . . little Ultra marine": quoted in Nijhuis (2018)

"The critical difference . . . conventional manner": Winawer, et al (2008)

ANIMALS

Richard Prum's book *The Evolution of Beauty* is a beauty itself: a personal narrative that is both readable and thought-provoking. *Structural Colors in the Realm of Nature*, by Shuichi Kinoshita, is densely written but contains a wealth of information on the subject.

"We will no longer . . . thing we see": Marc (1978)

"The most ingenious . . . in my life": Pepys (2003)

"onely fantastical ones": Hooke (1665)

"the beauteous and . . . the reflecting parts": Hooke (1665)

"But what a blue . . . to the heart!": Matisse (2013)

"spongy, honeycomb-like microstructure": Frank (1939)

"beautiful law of nature": Thayer (1896)

"Animals are painted . . . and vice versa": Thayer (1896)

"untenable", "absurd", "preposterous": Roosevelt (1911)

"What I would like to . . . scientific man": Roosevelt (1924)

"the peacock . . . a thousand times": Roosevelt (1911)

"This winter . . . blue jay's plumage": Roosevelt (1911)

"they would have . . . snow birds, for instance": Roosevelt (1911)

"Why are caterpillars . . . artistically coloured?": Darwin (1867a)

"It would be . . . a growing caterpillar": Wallace (1867)

"I never heard . . . prove it true": Darwin (1867b)

"None of these species . . . with impunity": Weir (1869)

"when we behold . . . her male partner": Darwin (1871)

"If female birds . . . impossible to admit": Darwin (1871)

"Why certain bright . . . are agreeable": Darwin (1871)

"In one's early days . . . as a myth": quoted in Steiner (1932)

"No bird . . . Mister L. in Uccle": quoted in Steiner (1932)

"You cannot imagine . . . you get up to": quoted in Sander (2012)

HERE WAS BLUE

"He looked . . . here was green": Hesse (2013)

"For our time . . . through the stubble": Jarman (1994)

"small and blue . . . eternal silence": MacLeish (1968)

IMAGE CREDITS

ACKNOWLEDGMENTS

Above all, my thanks go to the dozens of scientists who have talked to me about the color blue. Some of them share my fascination with it; I suspect others thought me a bit of an eccentric. All of them took time to answer my questions: Yoshikazu Tanaka, Naonobu Noda, Cathie Martin, Paula Rudall, Silvia Vignolini, Giovanni Verri, David Dobson, Bodo Wilts, Mas Subramanian and his wife Rajeevi, Leo Peichl, Thomas Metzinger, Ruth Siddall, Jo Volley, Heather Whitney, Russ van Gelder, Samer Hattar, Richard van Breemen, Richard Prum, Rasha Abdel Rahman, Martin Maier, Paul Kay, Asifa Majid, Ted Gibson, and many more.

My research in Japan was made possible only because I was working on a story for *Science* magazine. Thanks go to my editor, Martin Enserink, who, for many years, has been improving my stories in all respects—including the article "In Search of Blue"—and to the wonderful team at *Science*, who help me write stories like these and make them look great as well.

Over the years many friends and colleagues have read parts of my manuscript and given me important feedback; they include: Jon Cohen, Johanna Heinz, Kerstin Hoppenhaus, Johannes Heuckmann, Laura Salm-Reifferscheidt, Lampis Stavrinou, and Ragnar Vogt. Without their help, the book would have been worse. And without them, my life would have been poorer.

My editor, Birgit Schmitz, and the team at Hoffmann und Campe have shown more patience with me than I would have been capable of. And they brought me together with Hannah Kolling, who did the great graphics for the book.

A big thank you to Nicholas Cizek and the whole team at The Experiment, who have had to work with me during a pandemic

that has rarely given me time to think about anything else. That they still managed to shepherd through this English translation on time is entirely down to them.

Special thanks must go to my agent, Barbara Wenner, without whom this book probably wouldn't exist at all. The first time I told her about my idea of writing a book on the science of blue, she was enthusiastic right away. Over the years she listened to me again and again and then at the right moment said: "That's it, now write a proposal."

With the help of so many people, there is little in this book that I could claim to be completely "mine." Apart from one thing, of course: the mistakes. They are mine alone. Maybe I would have been able to catch another one of them, if I had gone over the text carefully yet one more time. But, as we say in German, you have to "make blue" now and then (see page 116).

ABOUT THE AUTHOR

KAI KUPFERSCHMIDT is a contributing correspondent for *Science* magazine, where he writes about infectious diseases as well as drug development, biotechnology, evolution, and science policy, and where his intrepid coverage of the coronavirus pandemic has gained international attention. He also writes for the German newspapers *Frankfurter Allgemeine Sonntagszeitung* and *Die Zeit*. When not doing these things, he is usually thinking about the color blue. He holds a degree in molecular biomedicine from the University of Bonn and lives in Berlin.

kaikupferschmidt.de | @kakape